HOLLYWOOD MOMS

PHOTOGRAPHS BY JOYCE OSTIN

HOLLYWOOD MOMS

PHOTOGRAPHS BY JOYCE OSTIN

Introduction by Carrie Fisher

Harry N. Abrams, Inc., Publishers

Editor: Ellen Nidy
Designer: Jeri Heiden
Contributing Editor: Wendy Goldberg

For more information go to www.joyceostinfoundation.com

Library of Congress Cataloging-in-Publication Data

Ostin, Joyce.
 Hollywood moms / photographs by Joyce Ostin ; introduction by Carrie Fisher.
 p. cm.
 ISBN 8109–4157–0
 1. Actresses—United States—Portraits. 2. Women motion picture producers and directors—United States—Portraits.
 3. Women entertainers—United States—Portraits. 4. Mothers and daughters—United States—Pictorial works. I. Title.

 PN2286.8 .O85 2001
 791.43'092'279494—dc21
 [B] 00-045374

Printed and bound in Hong Kong

Harry N. Abrams, Inc.
100 Fifth Avenue
New York, N.Y. 10011
www.abramsbooks.com

To my incredible husband, Michael, whom I cherish so much for being by my side every day, and for giving me
our three daughters, Anika, Leyla, and Annabelle, whom I adore and will always love.

To my father, Irving Fell, for always making me feel so special.

To my mother, Irene Fell, who taught me the tenacity that I have needed to endure.
I will always love and remember her zest for life.

To my sister, Robin Fell, who is there for me with our family challenges. I am so proud of you. I love you so much.

To Evelyn Ostin, my mother-in-law, who taught me so much about sharing, loving, and acceptance,
and who gave me the insight to have peace in my life.

To Mo Ostin, for his encouragement, and for always being there with the appropriate advice.

To Quincy. We've been through thick and thin together. I will always love you.

To Tom Laughlin—for showing me the way.

To my two dearest friends, Nathalie Marciano, who inspired me to create this book,
and Wendy Finerman, who has given me the focus and direction needed to accomplish this.

To Wendy Goldberg for all of your support, love, and dedication. You helped make this book happen.

To Carrie Fisher, aka Brain Sugar, you never failed to make me laugh. Thank you for sprinkling this project
with your humor and heartfelt insights.

To my amazingly creative art director, Jeri Heiden, for her eye, and her generosity in giving
so much time to this project.

To Cindy Gold, a great photographer, who assisted me whenever I asked.

To Arielle Ford and Brian Hillard, for all of their kindness and hard work.

To my editor, Ellen Nidy, who has made my first publishing experience incredible.

To Dr. Jim Blechman for your kindness, wisdom, and dedication.

To Dr. Dennis Slamon and all the doctors and medical staff at UCLA Medical Center for their dedication.

I extend my warm thanks to all the women who participated in this book, for all their effort and
desire to make a difference in other women's lives.

An extended thanks to Thea and Merv Adelson, Shelli and Irving Azoff, Johnny Barbis, Robert and Dori Bardavid, Red Barris,
Michelle Bega, Anne and Gary Borman, Andrea Burnham, Kelly and Renee Biren, Doritte Cohen, Carole and Bob Daly,
Bruno and Sebella Derval, Robin Druyen, Melissa Everett, Rabbi Eitan and everyone at the Kabbalah Center, David Foster,
David Geffen, Eve and Billy Gerber, Maria and Gary Gersh, Jody Gerson, Brad Grey, Andy and Evelyn Heyward, Ellen and
Michael Karpf, Dr. Serome Khalsa, Jena and Michael King, Chris Kitrinos, Dr. Arnie Klein, Fran and John Lasker, Bryan Lourd,
the Lucianos, Charles and Estelle Malka, Maurice Marciano, Brian Medavoy, Nicole Nassar, Phillip Nimmo, Kenny Ostin,
Randy Ostin, Jerry and Lynn Ostrow, Danica and Charles Perez, Richard Perry, Brian Pines, George Pipasik, Joanna and Sidney
Poitier, Nanci Ryder, Robbie Robertson, Liz Rosenberg, Bobbie and Eddie Rosenblatt, Lisa Rosenthal, Tom Rubin, Nita Shulman,
Carl Scott, Gayle Segal, Lisa and Jeff Sterne, Gary Stiffleman, Rose Tarlow, Karyn Tendler, Dr. Michael Van Scoy Mosher, Guy
Webster, Harriet Weintraub, Margaret and Howard Weitzman, Tina Yarbrough, Cynthia and Bud Yorkin.

ACKNOWLEDGMENTS

I'm a wife and mother of three young girls, Anika, Leyla, and Annabelle. I have a B.A. in Theater Arts. I've been interested in photography for three years.

My mother died of breast cancer thirteen years ago. I never had a clue about what it meant to have breast cancer—I thought you were diagnosed and then died eleven months later. I started getting mammograms at the age of thirty-five, and was diagnosed with breast cancer at the age of thirty-eight. I had a mastectomy and was treated with chemotherapy. But I never got over the possibility of having a reccurrence. It would fade in and out, and I was always scared.

Finally, three years later, my CEA blood levels started to rise, and my doctor got suspicious. Unfortunately, I did have a reccurrence, and this time I needed heavy-duty chemotherapy with stem cell marrow replacement to follow.

During this process I was pretty wiped out, but I kept focusing on my family. I was not ready to pass on. I wanted to fight. Dr. Dennis Slamon had told me he thought I could be cured, but I would have to be committed to this program, and I was. I could barely get out of bed during my month-long stay in the tenth-floor oncology unit of the UCLA Medical Center. Everyone there had cancer; it was a sad, yet hopeful, time. Thank God for my family and friends: I knew I had to survive to mother my three children.

After this ordeal I didn't ever want to look back. And I didn't want to live in fear anymore. What was left to do? Luckily for me, Dr. Dennis Slamon had just received FDA approval of a new antibody called Herceptin. I received Herceptin throughout all my chemotherapy treatments. I was actually the first person in the United States to get a prescription for this new drug. I have been on Herceptin ever since, although, as of yet, the medical establishment doesn't know how long a woman with my diagnosis should stay on it. Every day of my life I feel very grateful to God, to all of my doctors, and to my spiritual practices.

One night, after I'd begun to feel I was going to live, I went out to dinner with my husband and my closest friends, Nathalie and Maurice. At some point during the meal, Nathalie looked at me and asked, "What are you going to do to give something back?" I had often thought of this question, but hadn't known what I could do. We talked about my photography, and she asked me why I didn't do something with my camera and all the people I know. Immediate family and friends were excited about the idea, particularly Wendy Goldberg, who went out of her way to be helpful and supportive in every way she could.

So I set off to make a photography book about the celebration of life. And the love between mother and daughter. What could be more meaningful to me during this time of my life? Now I had found a way, I hoped, to bring smiles to people's faces and bring hope to other women who have to endure what I had gone through.

I have learned to live my life differently than I used to. My sister, who is also a breast cancer survivor, shares this. For each of us, every day is a gift and every day we feel we must express ourselves through our lives. Every day we must make the most of what we have. What can I do to make a difference in this world? That is my challenge.

I hope that by raising awareness, selling books, and raising money, I can help make breast cancer a less dangerous disease, a disease that women must no longer die from.

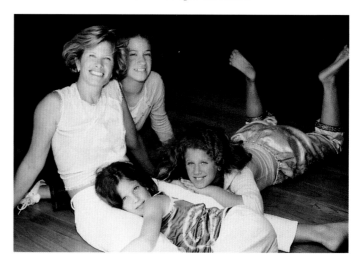

JOYCE OSTIN *& daughters*
ANIKA, ANNABELLE
& LEYLA

When I look into my children's eyes I see that we have shared a life full of love, hope, and faith. My greatest wish is that my three daughters and future generations will live their lives cancer free.

It turns out I have lived long enough not only to have a mother, but to be a mother.
It would also appear that not only do I have a celebrity mother,
I am a celebrity mother. And there's very little I can do about any of this
but enjoy it. Anything else would be unpleasant.

When I was very small, under doorknob height, a girl from the neighborhood came up to me and said, "It must be so great to have a movie star for a mom." I had no idea what she was talking about, not knowing what a movie star was. But I was thrilled to find out I had some kind of special situation brewing in my home. I headed back to find out just exactly what a movie star was.

I don't remember ever finding out.

I mean, I know what a movie star is now, sort of, but I don't remember it being a particularly vivid realization.

What I knew ultimately was this . . . my mother was extremely pretty. Prettier than other moms. Also prettier than me. The former was a good thing. The latter was complex. It would have to be remedied somehow.

My mother also worked. Other mothers—my friends' mothers—did not. This made my mom exotic. But it also made her less available to me. My mother did not belong to me exclusively. I had to share her with the world. This sort of sharing could prove to be unsanitary. It could also stretch my mother pretty thin. I wanted to make sure I got the biggest helping of whoever she turned out to be. Everybody else could haggle over whatever remained. Including, and especially, my little brother.

A relationship between a mother and daughter is flammable stuff in adolescence. This would appear to be the law. With exceptions, of course. But my relationship with my mother during adolescence was no exception to this rule.

When I was younger, I thought my mother was perfect. She was beautiful. She was funny. She was loving and kind. And she could sing—which was great when I couldn't fall asleep and she would scratch my back and sing me songs that she made up on the set especially for me.

My mother got dressed up and made movies. What could be better than that? My brother and I visited her on the set. She was both parents to us. She was my world. She was, in a word, perfect.

She could only fall from the pedestal I put her on.

As I became more aware of the outside world, or, more particularly, television's version of the outside world, I realized that my mother was not like the mother on "Father Knows Best." She didn't wear an apron and cook and drive me to school. Although she was actually *in* movies and on television, she rarely played someone who *did* cook and wear an apron and drive children to school.

Then, during my adolescence, I found out that my mother was human. She had problems. Sometimes the world was too much for her to bear. This was not alright with me. Why hadn't she checked with me before turning up flawed and dysfunctional? I would've told her that her having problems of her own did not meet with my approval. Her world was supposed to revolve around me. Her having difficulties couldn't have come at a more difficult time. Couldn't she have scheduled all her messes to come *after* I left home?

I went to war with my mother. I rolled my eyes at most things she said. This was especially true when she made the absurd suggestion that I behave differently, or according to her rules. Who was *she* to tell me how to behave? Didn't she see that I was

My mother and I went down to the
Midnight Mission in downtown L.A.
to serve Christmas dinner to the
homeless. While she and I served
turkey and potatoes and vegetables,
Billie passed out soap and phone cards.
It's one of the nicest things
we have done as a family.
The weirdest thing we do is not eating
dinner at the dinner table. Instead we
have our meals on trays in front of the
TV. (Please don't tell anyone this.)
—Carrie Fisher

There are too many wonderful
moments for me to pick out just one.
I am just blessed God gave me such
a wonderful daughter.
—Debbie Reynolds

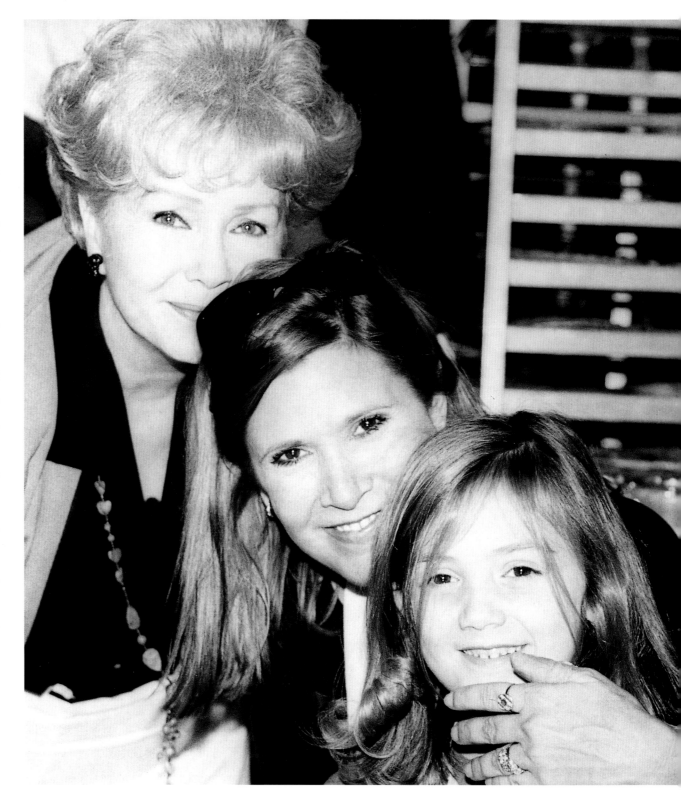

almost grown up and not in need of her antiquated, suspect counsel?

Apparently not.

It took years for me to be confronted with my own flaws. And in order to forgive myself those, or even to admit to *having* them, I had to forgive my mother for being less than perfect. For turning out to be who she *was*, as opposed to who I wanted her to be.

I began the long road of repairing our relationship.

For years my mother was spooked by our estrangement. Our necessary estrangement, in some ways. Not that we ever stopped speaking. We couldn't. We were too involved. Too much alike. I saw her as bossy, so I bossed her right back. We now had far from a perfect relationship. What we did have was a real relationship. Complete with fighting, and guilt, and bad behavior. These were the things I contributed to our relationship. And I'm not too proud of that.

Having a daughter of my own made me realize what my mother had been up against while raising me. Bringing up two kids on her own, and even taking on three of her second husband's children, while having a full-time career couldn't have been too easy.

Becoming a mother was . . . well, initially it was very intimidating. I mean, I didn't know whether I would be good at it at all.

You know that poster that shows a cartoon of a woman looking distressed, with the caption, "Oh my God, I forgot to have children!"

Well, I want to see the same cartoon of the distressed woman saying, "Oh my God, I remembered to have children!"

I remember when my daughter, Billie, was very small, newly born. I would continuously check to make sure she was still breathing. She was so new in this world, it didn't seem as though she was fully committed to staying. How do you hold a child? Why didn't someone tell me that breast feeding was uncomfortable? Are they supposed to be sleeping this much?

The bottom line to all this was I didn't know how to be a mother. I hadn't been all that great at being pregnant, but at least that had only lasted nine

This seemed very apt when applied to parenting.

I didn't know who to ask how to be a mother. God forbid I ask my own mother. Then she would know I didn't know. I hadn't really paid attention to how my mother was a mother. I only paid attention to her parenting when I wanted to object to it. Besides, perhaps being a mother in the fifties was different than being a mother in the nineties.

Naw.

One of the reasons I had a child with Billie's father, Bryan, was that I knew he would know how to parent a child. I certainly didn't have the same confidence in myself. When I held her, I thought I would drop her. When she slept, I thought I would lose her. I loved the smell of her, loved the way her fair hair swirled into a circle at the back of her tiny head. I would watch her all the time. Who would she turn out to be? I called this watching BTV. Baby TV. I watched her discovering her hand. Hand TV.

I read somewhere that there are two groups of people, those that have kids and those that don't. And the people with children speak their own special language. Since having a child I can look at any infant, any child, and tell you within six months how old that child is. I want to talk about them. Not all the time, but most of it. Everyone who has had a child has her own story about her pregnancy, the birth process, and endless stories about the child itself.

I know my daughter. I major in Billie Catherine. I know her smell, what foods she likes, what clothes she wears, what cartoons she watches, that she likes Austin Powers, dogs, Rugrats, Christina Aguilera, pizza, vanilla ice cream, and that her favorite color is blue.

On the other hand, I know my mother likes old movies, guacamole, molasses chips from Sees Candies, silver picture frames, reading gossip magazines, popcorn, German Rhine wine, and the color green, like her eyes.

We learn who we love. We want to cater to their likes, contribute to their happiness. Take care of them when they're sick, comfort them when they're upset.

Whenever I get sick, I still want my mommy. I want her to scratch my back,

DEBBIE REYNOLDS & CARRIE FISHER, *actresses*
BILLIE LOURD, *daughter & granddaughter*

months. This mother thing seemed to go on and on indefinitely. And it changed all the way along, didn't it? I had a friend who slowly went blind, and he used to say, "I wish things would stop changing, so I could know what to get used to."

bring me Seven-Up and soup, put a diaper with Vicks VapoRub on my chest, and tell me everything is going to be okay.

And when my daughter feels unwell, I scratch her back, bring her Seven-Up and

toast with strawberry jam, skip the Vicks, and tell her everything is going to be okay.

I love having a mother almost as much as I love being one. I love being needed, being asked what something means, can we get a new puppy (no), go to the park (yes), to the movies (yes), to Disneyland (yes), skip school (no), skip French (no), take tap dancing with grandma (yes) . . . you get the general idea. There's not a lot of "no" in our relationship. Just enough.

I leave the rest to her father.

Sometimes, following my daughter, I feel like a Secret Service agent or a lady-in-waiting. Or both. It's this complex balancing act. I have to set limits, which is not my greatest talent. What happens when I ask her to do something she doesn't want to do? Won't my popularity with her suffer?

I have to protect her without smothering her. I have to provide for her without spoiling her. To prepare her for life as best I can. How do you prepare someone for life? How do you get your child not to grow up too quickly, but to move in a steady pace toward maturity?

Being a mother is an unbelievable responsibility. When you think of all the ways you could mess up your child, well, it's a little intimidating, to say the least.

Sometimes I feel I make it up as I go along.

Well, wait, it's not that random.

Early on I thought I would read as many books as I could. To prepare. To cram for motherhood. I went to child psychologists, took courses, anything to ensure I did a great job at this. To ensure that Billie would come out perfect. A good person, who felt good. Sure, there may not be a definitive way to raise a child, but I was going to learn as much as I could. Leave nothing to chance. One didn't have to get a license to be a mother, but I was going to act as though you did. But, finally, after all that, I do a lot of the things my mother did.

Jung said, "What do a grandchild and a grandmother have in common?"

Answer: "They share a common enemy."

So, one day I will be caught in the love affair between my mother and my daughter.

It has already begun.

When my mother isn't working, I become her job again. As though she's going back to raising me. She wants to pick my boyfriends, manage my money, and teach me how to raise my child. God forbid my mother ever retires. My mother applying the same energy to controlling me as she does to doing her show . . . well, let's just say I don't stand a chance. I lose my vote. I do it Debbie's way. Or no way. That way madness lies. My mother has no down time. The Debbie theater is never dark. My mother is a force of nature. My mother has character, and kindness, and backbone. And these are the gifts she's given me. Among the

gifts. And this is what I see in Billie. No matter how far away Billie gets from me, these are the qualities that will bring her back. They probably are part of what takes her away. What convinces her that she can do it on her own. And she probably could. And so could I.

But who'd want to?

I now hear my mother's voice when I'm disciplining Billie. "I'm going to count to three . . ."

"And then what?" I always wait for her to ask. What does she think I'm going to do after three? What did I think my mother was going to do?

Sometimes I did what my mother told me to do, and sometimes I didn't. And, man, you didn't want to be me when I didn't do what she wanted. My grandmother bossed my mother around, my mother, in turn, bossed me around, and now it's my turn to boss Billie around. And when I do happen to tell Billie to do something, "because I said so," she doesn't look exactly thrilled. So we are four generations of women who learn from example to be strong and opinionated, and then, when that strength is turned on the person who taught it to us, all hell breaks loose.

Well, maybe not *all* hell, but certainly some. Enough to make Christmas a little uncomfortable at times.

And what am I going to get from being an example of strength to my child? A damned uncomfortable power struggle come Billie's adolescence.

But what *she's* going to get at the other side of all this is, I hope, a sense of self, and strength, *and* humor, that make life not only something to get through, but something to actually enjoy. I know that's what my mother's strength has given me.

I know that when the going gets rough I can go to my mother. She will comfort me and take my side and nurture me back to where I can nurture myself. Knowing that my mother is in my corner doesn't make me feel as though I'm in a corner at all. It makes the world a friendlier place to be.

My mother was always my grandmother's little girl. She became her little girl whenever they were together. In the same way, I will always be the child I was to my mother, and Billie will always, in some way, be a child to me.

It's difficult to believe that your children can function well, if at all, without your direction. You get so used to guiding them.

What is the cut-off age for all this?

As it turns out . . .

Never.

—Carrie Fisher

*What are the most nourishing
moments you've shared
with your mother or daughter?*

Every mother has certain moments, little catch-your-breath flashes, that come to her about her children and then are there, held forever. One of mine occurred when my first child, Lilly, was one day old. I remember looking at this baby in my arms, and her already steady blue gaze found mine. I remember thinking, "Oh my God! She is so powerful! She is so independent!" It instantly seemed a strange thing to think about a tiny newborn but I now know that I was gazing past her little body into her soul. Because years later, that is just who she is. For me, the essence of Lilly has never changed from that instant. Now I know much more about her, of course. I've developed an addiction to her infectious laugh. I am familiar with her fairness and her quiet confidence. I shake my head continually at the depth of our conversation and our ability to be ridiculously shallow over clothes an instant later. I'm proud that she's been a clerk in a store, worked the coffee counter in a bakery, and was a busgirl in a restaurant. She breaks the stereotype of the "Hollywood Kid," and it thrilled me when the woman who ran the low-income daycare center where Lilly volunteered was visibly stunned when she realized that the beautiful, unassuming young woman who had worked for her for months was the child of celebrities. I am lost in love for her. She's a grace upon my life.

MARY STEENBURGEN, *actress*
LILLY McDOWELL, *daughter*

MADONNA, *singer & actress*
LOURDES LEON, *daughter*

Madonna was shooting her album cover when I got to the studio. She and Lourdes came with me into an empty studio where music was playing. Lourdes' shoulders started moving to the beat. Couple that with how comfortable she was in front of the camera. She is clearly her mother's daughter. —J.O.

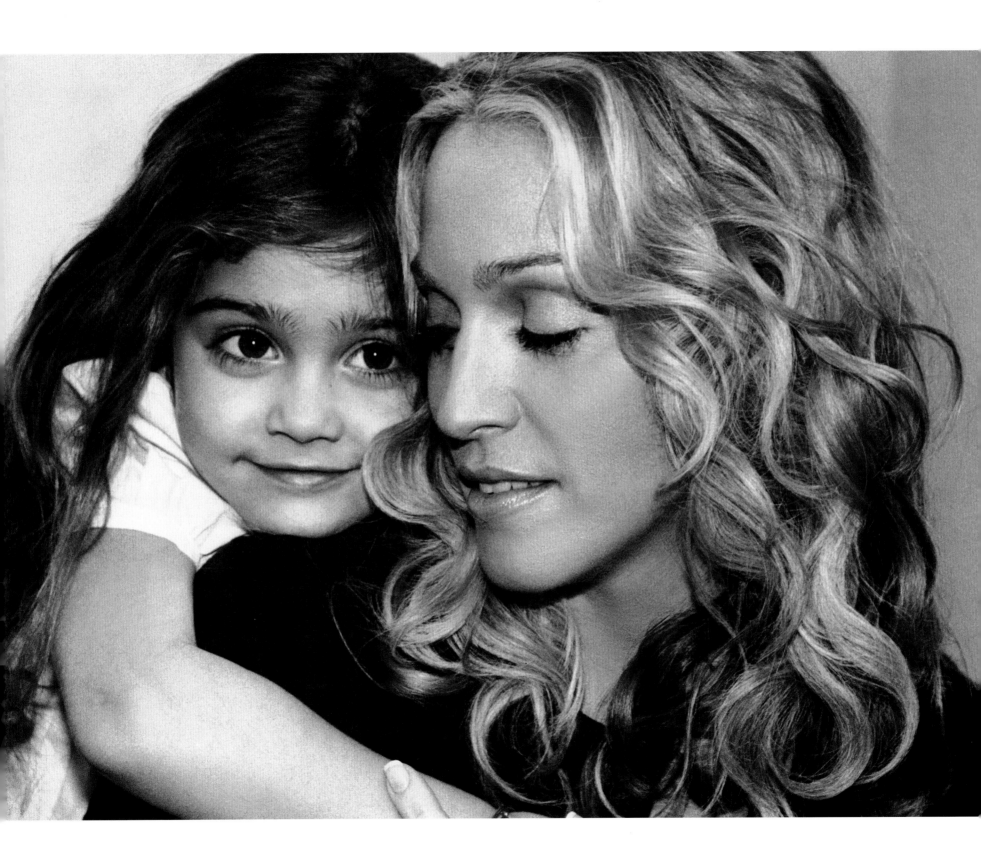

My mother – the one who taught me to follow my heart,
trust my instincts, and always believe in myself.

–Hilary Swank

I bless the day she came to me . . .
My little girl with the big brown eyes.
Through the years
she made me laugh so hard I cried.
She shared her dreams.
She shared her heart.
We shared the risks.
We share our love.
And, she taught me courage to find my way.
What beautiful, joyful moments we have had –
me and my little girl with the big brown eyes.

–Judy Swank

HILARY SWANK, *actress*
JUDY SWANK, *mother*

When I was shooting Hilary and her mother Hilary turned to her mom and said, "Mom can you believe we came with $75 in our pockets and now we are going to be in a book together?" This was the last photograph I took for the book. It was on Mother's Day. I felt so honored to be able to take their picture. I think at that moment we all felt grateful. They are especially down-to-earth women. –J.O.

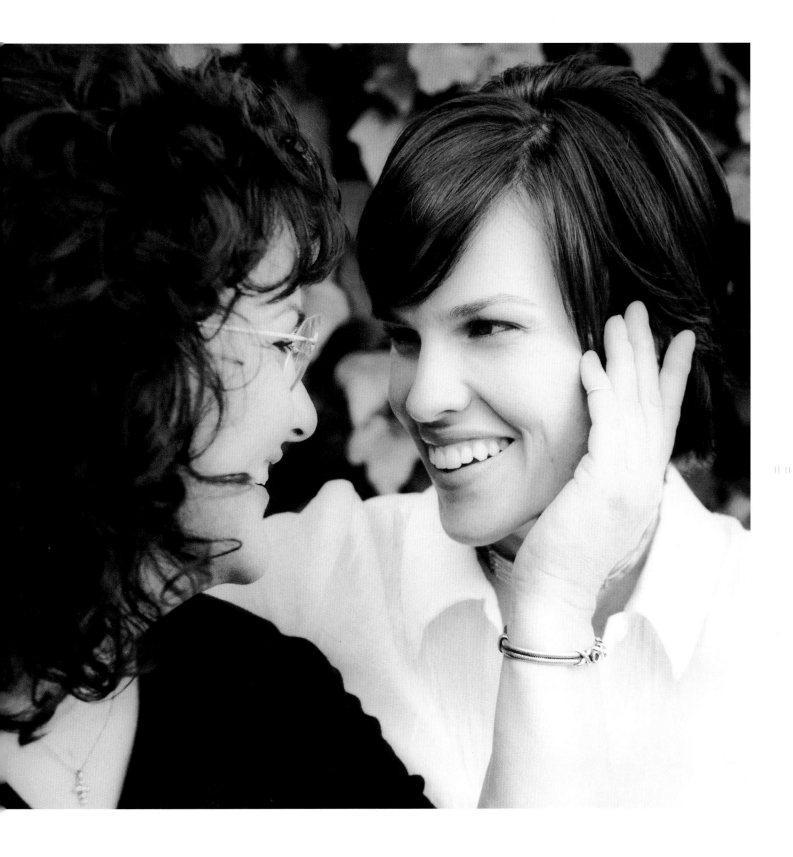

Now that my daughter is a full-fledged teenager, I am reminded of a magical
moment I managed to catch when she was just a tiny little thing.
Her crib was in my bedroom, and as she pulled herself to a standing position
for the first time, a mixture of exhilaration, fear, and empowerment
washed over her face and is clear to me still. I remember that moment
as it has played out in other stages of her development and mine,
reminding us to celebrate the joy of her growth by letting her go, and
resisting the temptation to pull her up myself, yet always being near, should she fall.

SUSAN SARANDON, *actress*
EVA AMURRI, *daughter*

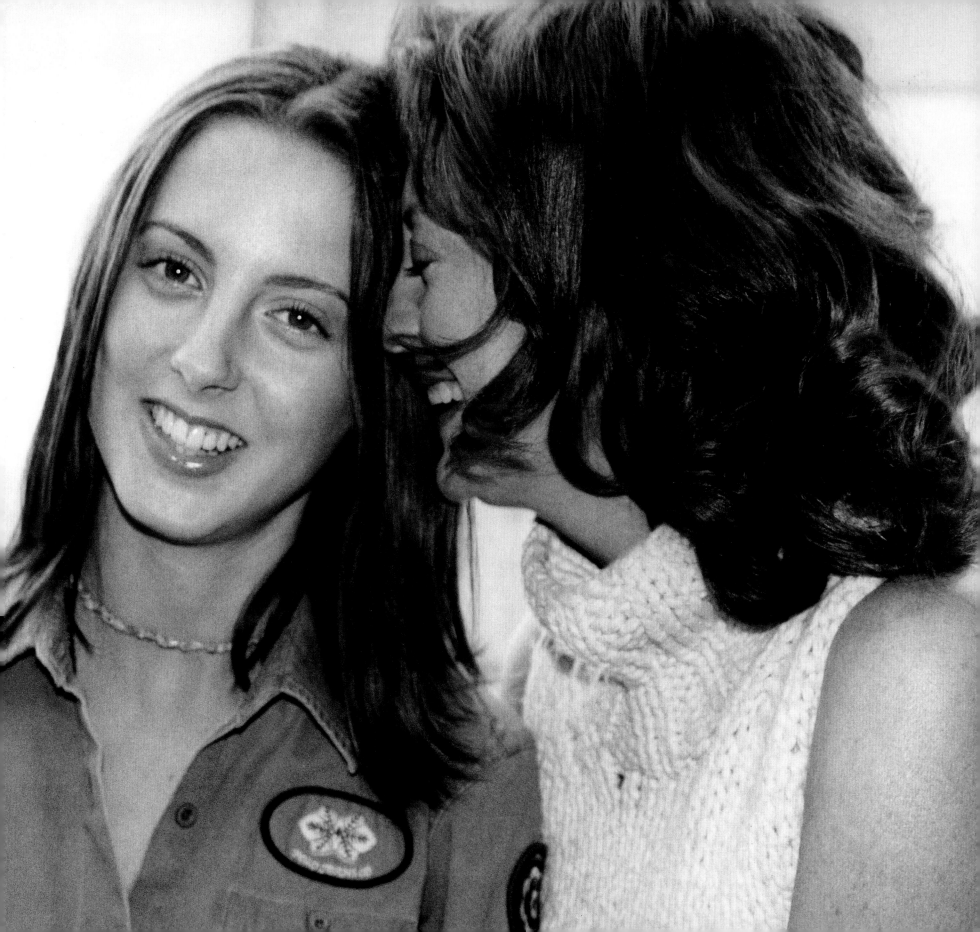

MICHELLE & DEDEE PFEIFFER, *actresses*
LORI COLE, *sister*
DONNA PFEIFFER, *mother*

Michelle and her sisters are very bonded to each other and to their mother. I got a sense of a strong family love. –J.O.

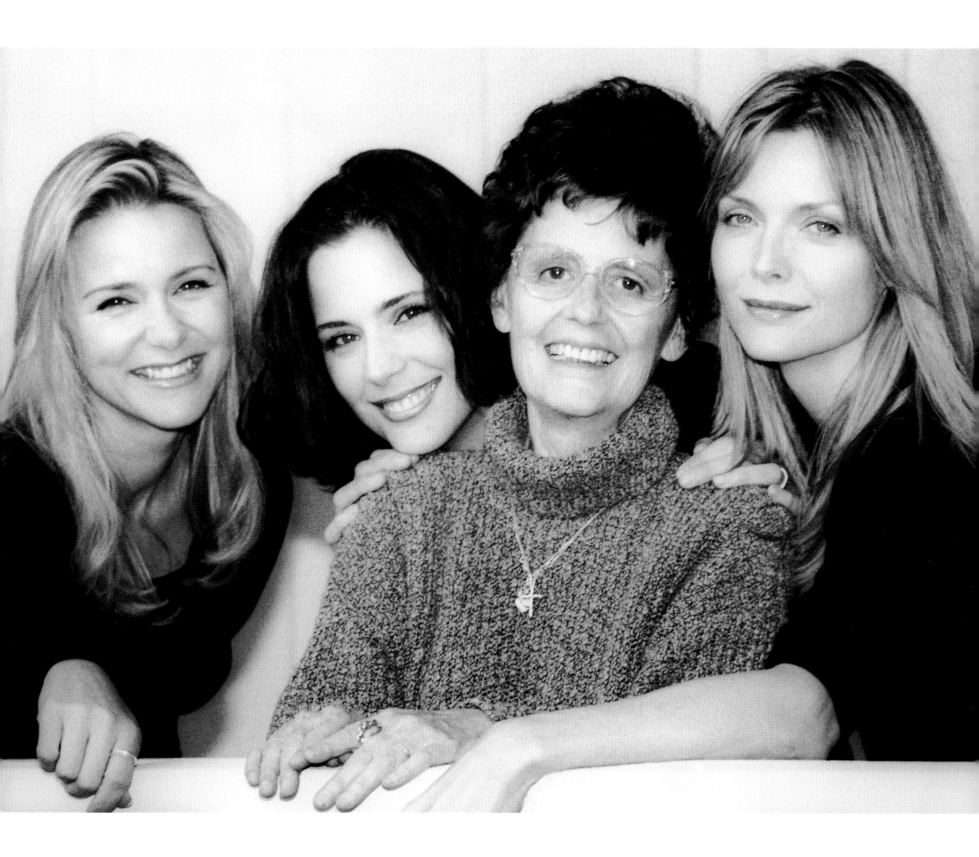

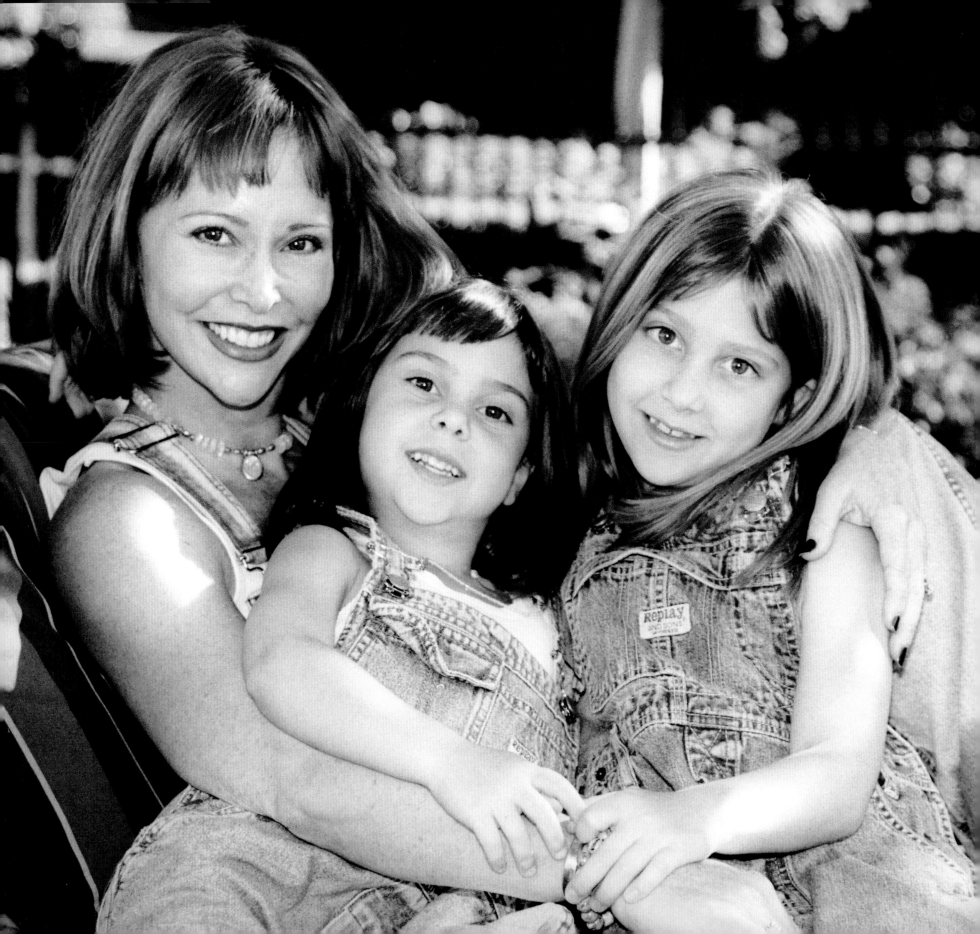

The intimacy between husband and wife is small potatoes compared to that shared by mothers and young daughters. Since my first little female could walk, I haven't gone to the bathroom, shaved my legs, or attended to my menstrual cycle without a very curious peanut gallery watching. I still trip over them if I change positions too quickly, since they are generally leaning on me, inspecting my hair roots, or standing between my legs whenever I come to a momentary standstill—which I firmly believe to be further evidence that they are forever searching for the path back into the womb.

I call them my "Polly Pockets," since I am certain they would happily live in a pouch around my waist or between my breasts for as long as I could bear the burden. From there, they would tell me if I have lipstick on my protruding eyetooth or questionable breath, all the while eavesdropping on my every conversation and digging for still more details. Nine times out of ten, I loudly register my chronic claustrophobia—usually as we all three lie in a tangled heap on the floor after our six legs have crossed us up. But, deep in my soul, I still have the prescience to know that our eventual disentanglement will be a kind of death for me.

I know their scents as familiarly as I know my own bed or my favorite old sweater, and they know mine. Like a trio of orangutans, we pick each other's hair, nose, and lint, and we soothe ourselves by imbuing ourselves with our family's "girl" aroma. I caress their skin like a child fingers the satin edge of a blankie and I can't keep my hands out of their spun silk hair, and I secretly mourn those days when I, too, was as soothing to the touch. What will I do when they begin to claim their personal space? Take it personally, of course, but I'll also promise to do my best to control my incessant petting. Please, God, let me someday relive it all through the intimacies with their children. Otherwise, I'll have to take up smoking or needlepoint to try to fill the void.

VICKI IOVINE, *writer*
JADE & JESSICA IOVINE, *daughters*

Every single time I look into my baby's eyes.

MELANIE GRIFFITH, *actress*
STELLA BANDERAS, *daughter*

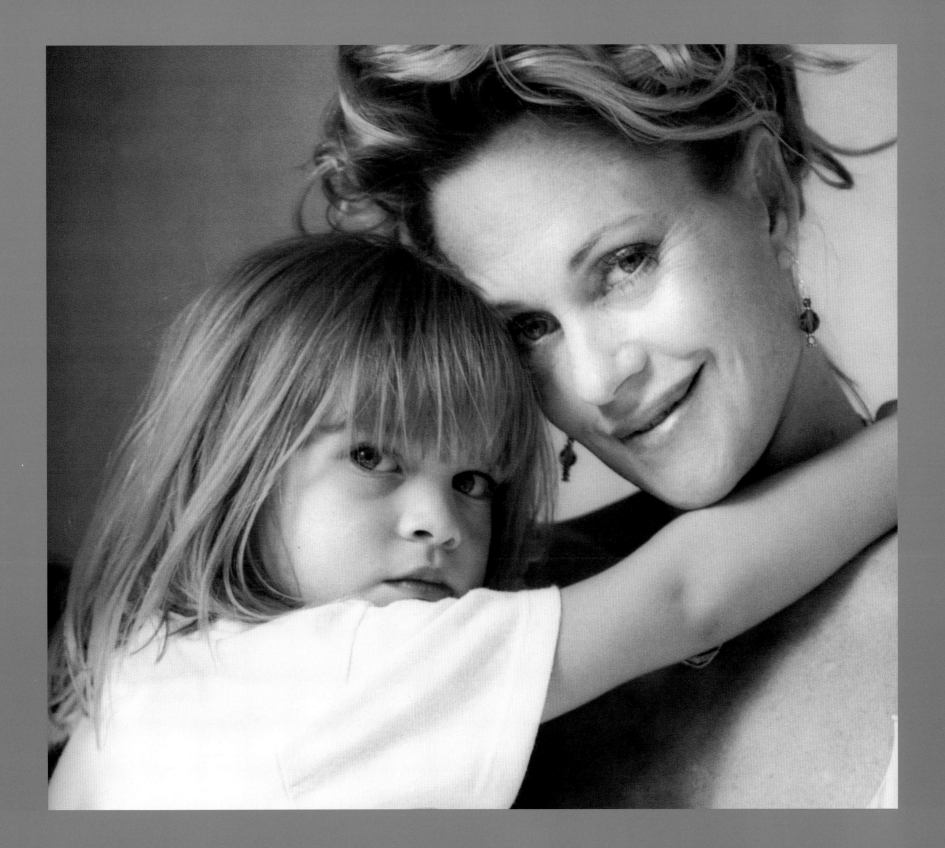

All my life I remember my mother saying to me, "Remember to pray to God—get quiet and ask, who is Patricia?" It was always important to her that we each had a strong sense of ourselves.

About six months after she died, I remember I had to go on the *Tonight Show* to do promotion for a movie I had coming out, and I was grieving so much I didn't think I could do it. Then I heard my mother's voice telling me to "Get quiet and ask God, who is Patricia?"

When I did that I felt the joy and humor that I had learned from my mother. It was always important to her that we were free to be ourselves—no matter what anyone in the world thought. That we were free of the censorship of unimportant petty judgments—that we could feel free to celebrate life. Well, it was near Easter and I decided to wear an Easter Bunny suit. This idea met with opposition from some of my business associates but I wore it anyway, and I don't think I have ever felt as much my true self in any moment of my public life.

We were very poor growing up. But mother loved children—loved mothering—and every Easter she would make us clues for a treasure hunt. She gave us candy, imagination, and the magic of love. So much of what is good in me, so much of what is pure in me, is directly from my mother.

And although I have millions of memories of her—the memory that I want to share with you is the memory of how love is eternal—how someone can change you forever, and that the love my mother shared with me and so many people will continue and that she will still force me to grow, push me to greater truth and a nobler cause. Because that is who she is and her love and counsel are all around.

Whenever I remind myself that my senses are limited, I can feel her—she is here, and her death or a thousand years will never take her away.

—Patricia Arquette

ROSANNA AND PATRICIA ARQUETTE, *actresses*
MARDININGSIH ARQUETTE, *mother*

The birth of my daughter was the most nourishing spiritually, and it opened me up. Also, in many ways the death of my mother, as painful as it was. I was able to share her death with her, and it was a beautiful experience—to watch her let go with grace and beauty.

—Rosanna Arquette

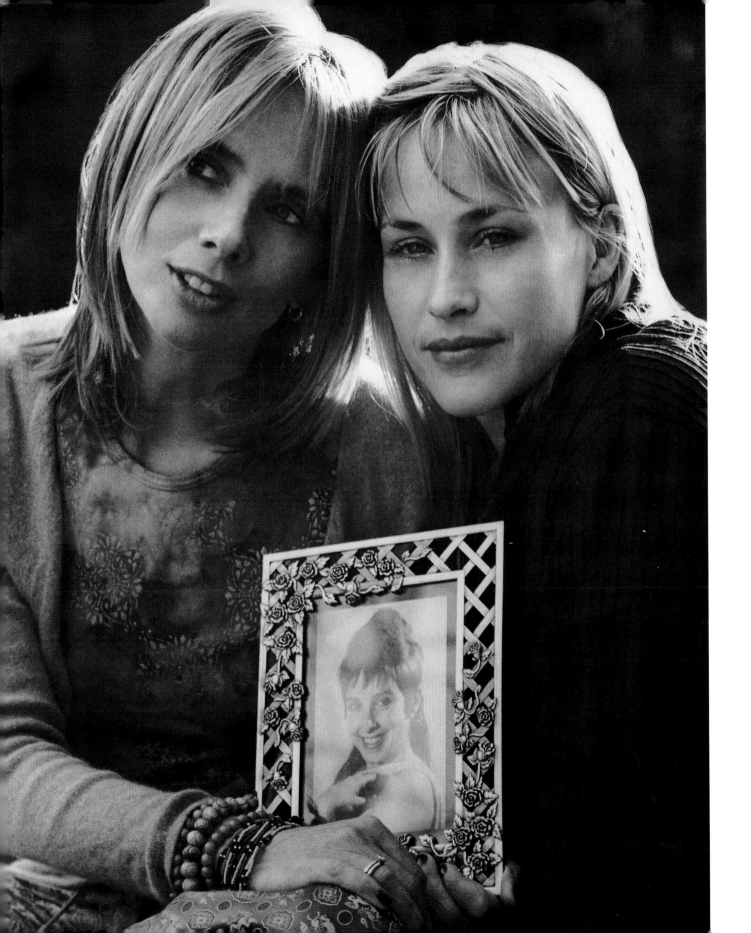

Chloe and I would (and still do) take a tray into bed, light the fire, and watch Disney videos: *Bambi*, *Sleeping Beauty*, and *Lady and the Tramp*.

—*Candice Bergen*

Singing in the car together.

—*Chloe Malle*

CANDICE BERGEN, *actress*
CHLOE MALLE, *daughter*
FRANCES BERGEN, *mother*

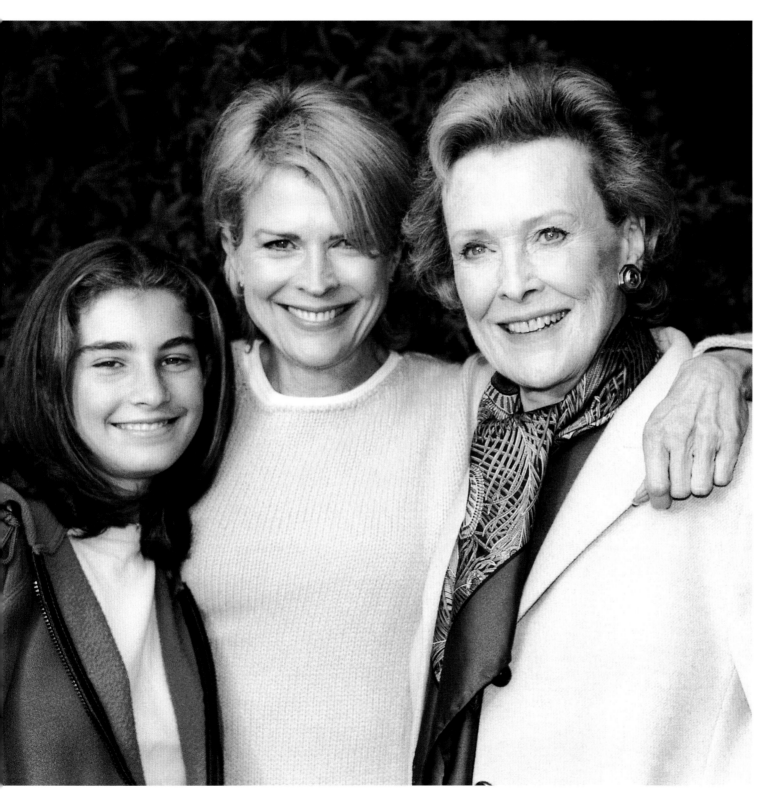

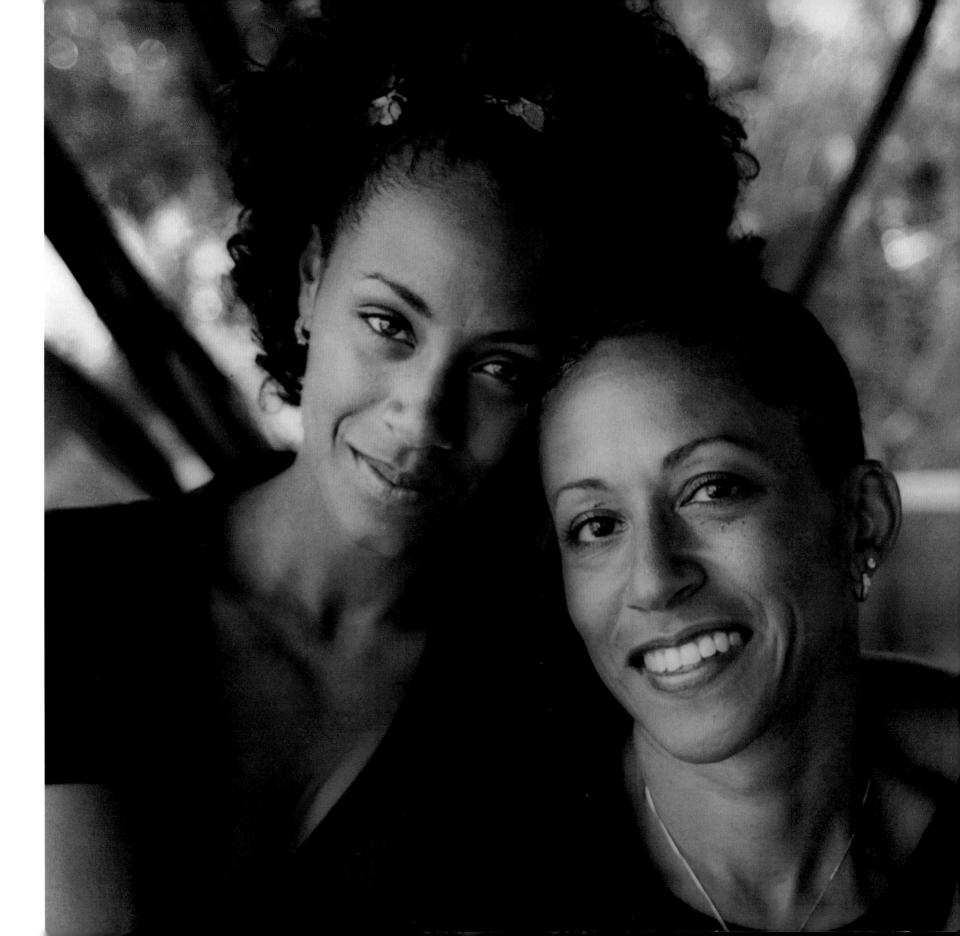

When thinking of a nourishing moment I have had with Jada, my initial thought was of a moment when Jada was nourishing me. That moment was seeing Jada with her own child. I was very young and self absorbed when I had Jada, and so I didn't appreciate the significance and importance of being a mother. I love that Jada waited until she had found a man who would be committed to her and until she herself was mature enough. It has been moving to watch Jada throw herself into motherhood so unselfishly.

My other nourishing moment was seeing Jada on the big and small screen for the first time. Jada and I have had some difficult times, and when I let her leave for Los Angeles there were many people who questioned my decision. However, all questions were put to rest when I first saw her on the screen, because Jada was fulfilling her dreams and doing the very thing she was born to do.
–Adrienne Banfield Jones

JADA PINKETT SMITH, *actress*
ADRIENNE BANFIELD JONES, *mother*

Thank you, God, for love and laughter.

DYAN CANNON & JENNIFER GRANT, *actresses*

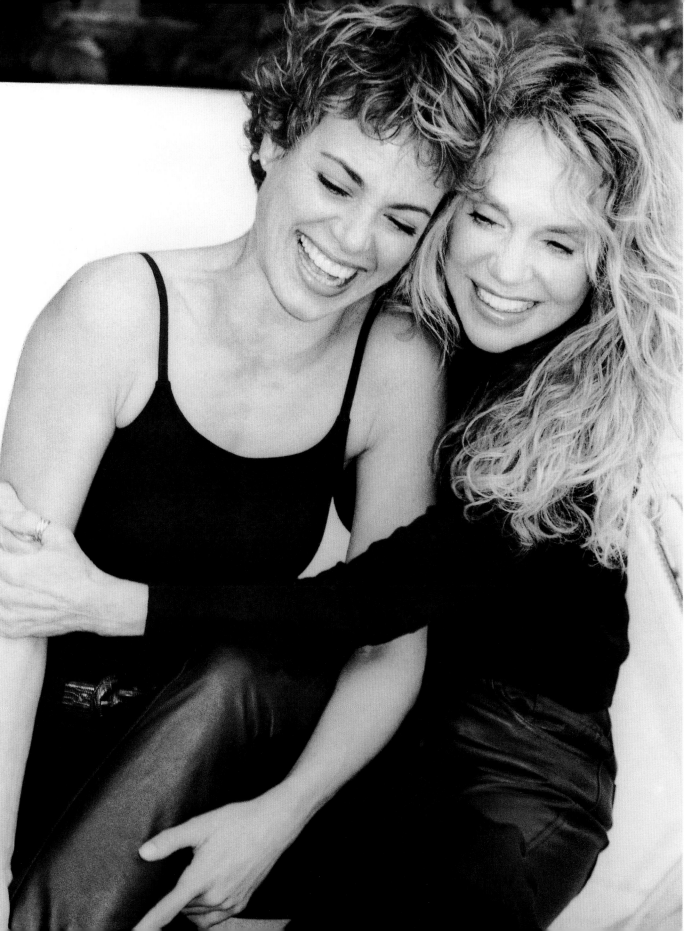

Nourishing moments never end—they are always a work in progress.

JOANNA POITIER, *actress*
SYDNEY & ANIKA POITIER, *daughters*

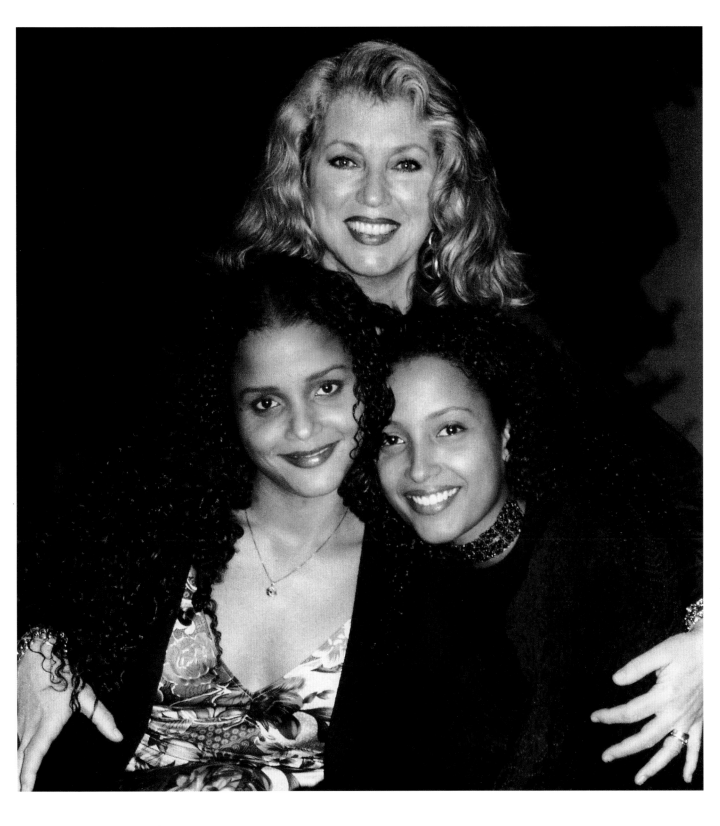

i realize now. it is our laughter. a common sense of life's humor.

k.d. lang, *singer*
AUDREY LANG, *mother*

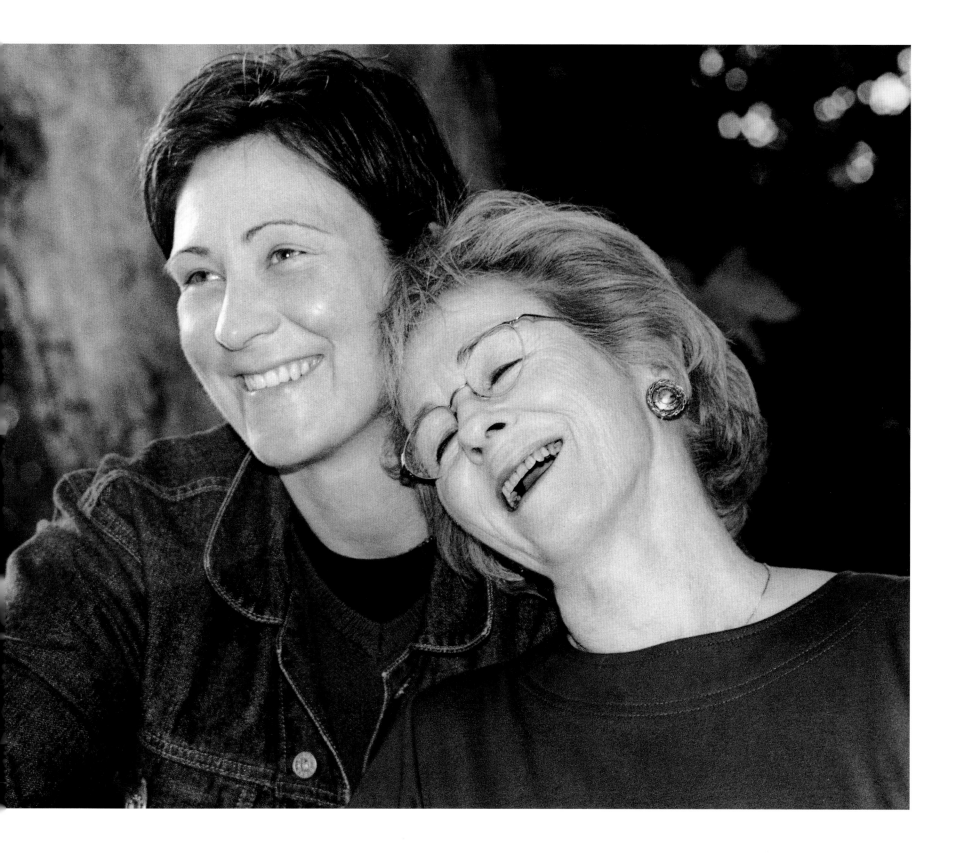

When I see my daughters and their brother all asleep in a deep sleep
in one bed, I just sit there for a long time thinking they'll have each other for
a long time, thinking they will love each other and be together forever: that was always
my dream when I was little, not to be alone, to have a sister or a brother.
Nothing makes me feel more proud . . . I love them so much.
They're such amazing people.

NASTASSJA KINSKI, *actress*
KENYA JONES & SONJA MOUSSA, *daughters*

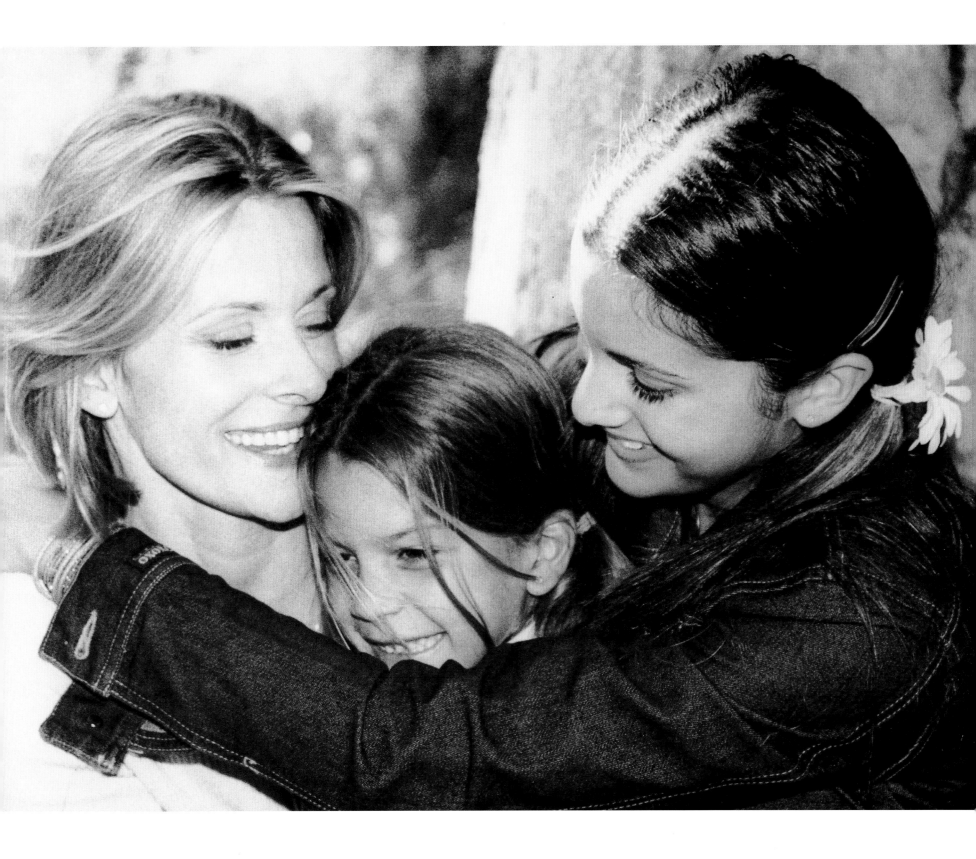

Infancy, the morning of life! How beautiful it is! The unfolding of a human life, the development of a human soul. Stella Mae came into this world, prolonging my mother's life. When the time had come, and my mother was lying in the hospital, hours away from departing this world, I laid Stella between her legs, asleep with her arms stretched out, and realized in that defining moment: One life is taken and one life is given.

Belle is the child who will put her arms around you, lay your head on her chest, and whisper in her husky voice the deepest phrases of love, loyalty, and endearment.

Half Moon Island, Antarctica, December 30, 1999 I watched Danielle, our eldest daughter, move away from everyone and go and sit on a rock, quietly, waiting for a colony of chin-strap penguins to make their way to her—a big-eyed child of wonder. Danielle felt she had come home, and I experienced the fullness of watching my child's dream being realized.

DONNA DIXON AYKROYD, *actress*
DANIELLE ALEXANDRA,
BELLE KINGSTON
& STELLA MAE AYKROYD, *daughters*

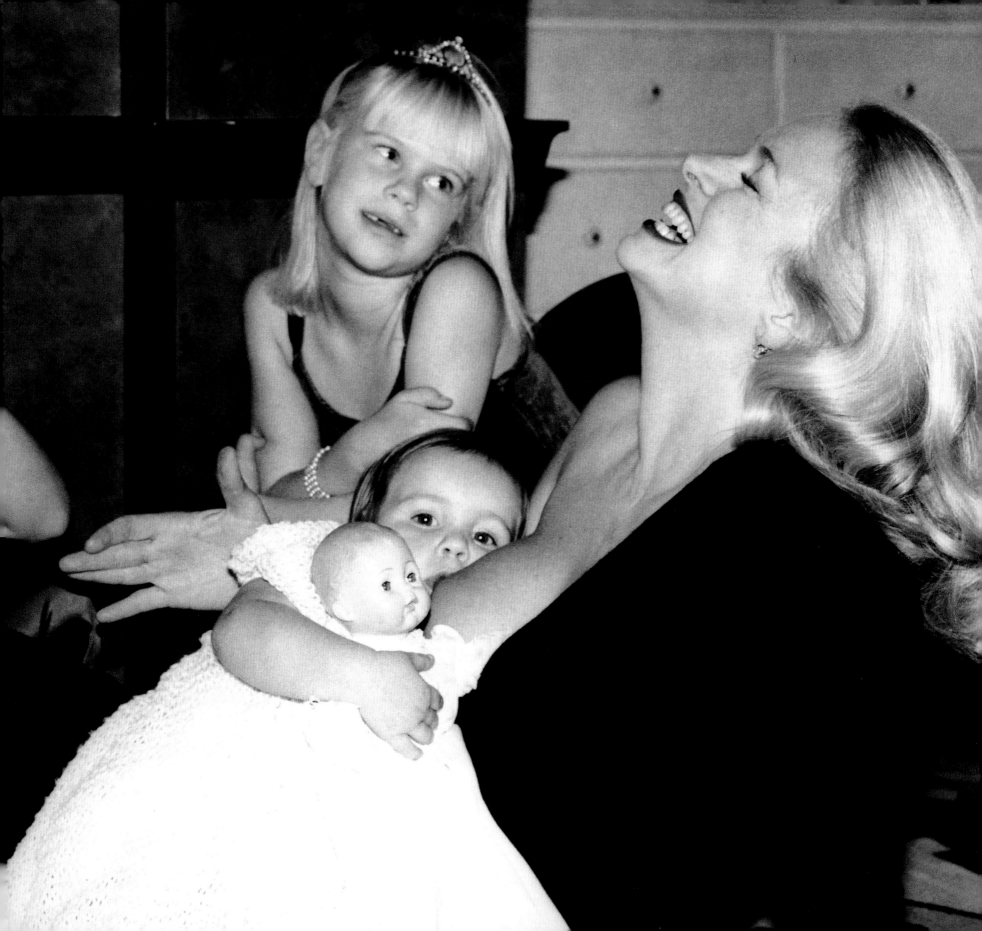

GILLIAN ANDERSON, *actress*
PIPER ANDERSON, *daughter*

Gillian and Piper had such a natural love that I could feel how much Gillian enjoyed being a mother.
Her easiness with her daughter and herself made me feel full of love. —J.O.

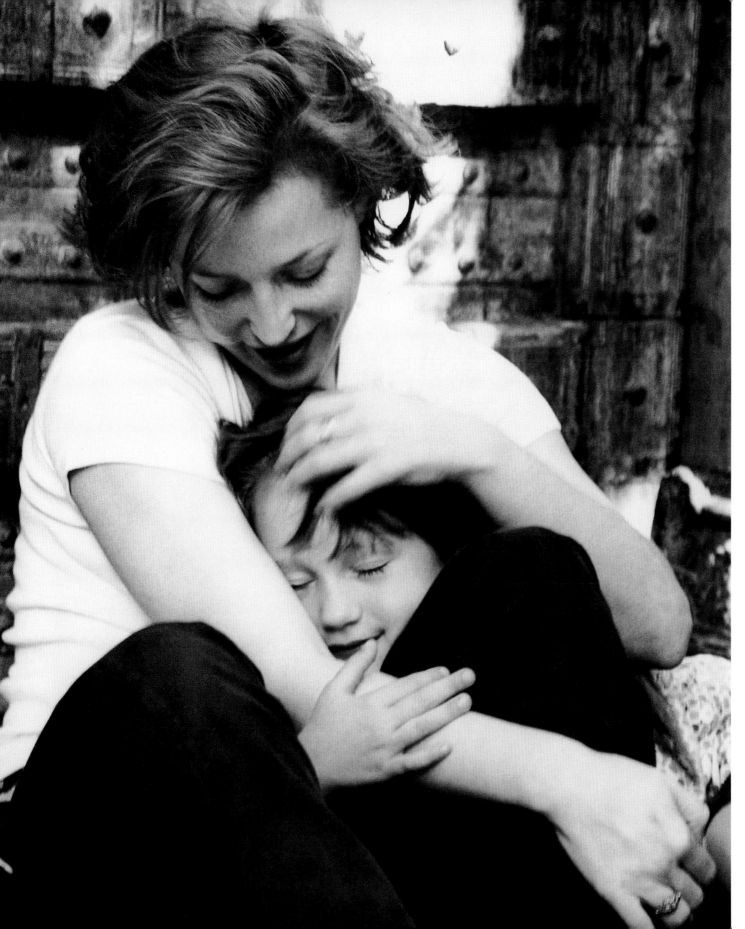

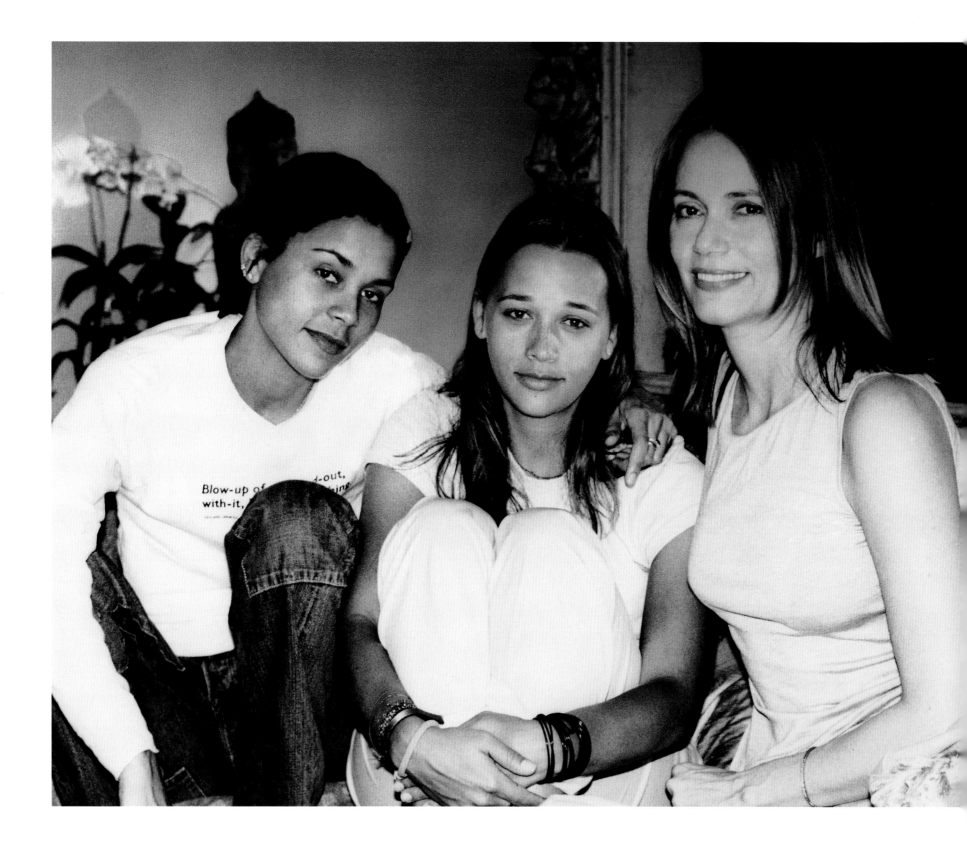

Being there 100% for each other.

Enhancing our spiritual path together and supporting each other individually.

Having our sleepover dates, baby blanket, cell phones, and all.

Always finishing each encounter and phone call with "I Love You!"

Listening with love.

Holding hands and hugging.

Hearing each other's problems.

Having lots and lots of laughs.

PEGGY LIPTON, *actress*
KIDADA JONES, *designer & model*
RASHIDA JONES, *actress*

I love putting Chelsea to bed.
We have a ritual: two books and two songs.
She is into "The Sound of Music" lately,
and we trade off lines to "My Favorite Things."

Rosie: "Raindrops on roses and whiskers on kittens"
Chelsea: "Bright kitchen turtles and white wooden mittens"
Rosie: "Brown paper packages tied up with string"
Chelsea: "All of these are my most favorite things"

Close enough for a 2-1/2-year-old.

ROSIE O'DONNELL, *talk-show host*
CHELSEA O'DONNELL, *daughter*

PENNY MARSHALL, *director & actress*
TRACY REINER, *actress*

Tracy's motherhood really enhanced her relationship with her mother. Penny enjoys being a grandmother almost as much as she enjoys being a mother. It gives her an excuse to buy all the toys she wants. She pretends they are for Spencer, when they are really for both of them. Needless to say, Christmas is big at the Marshall house. —J.O.

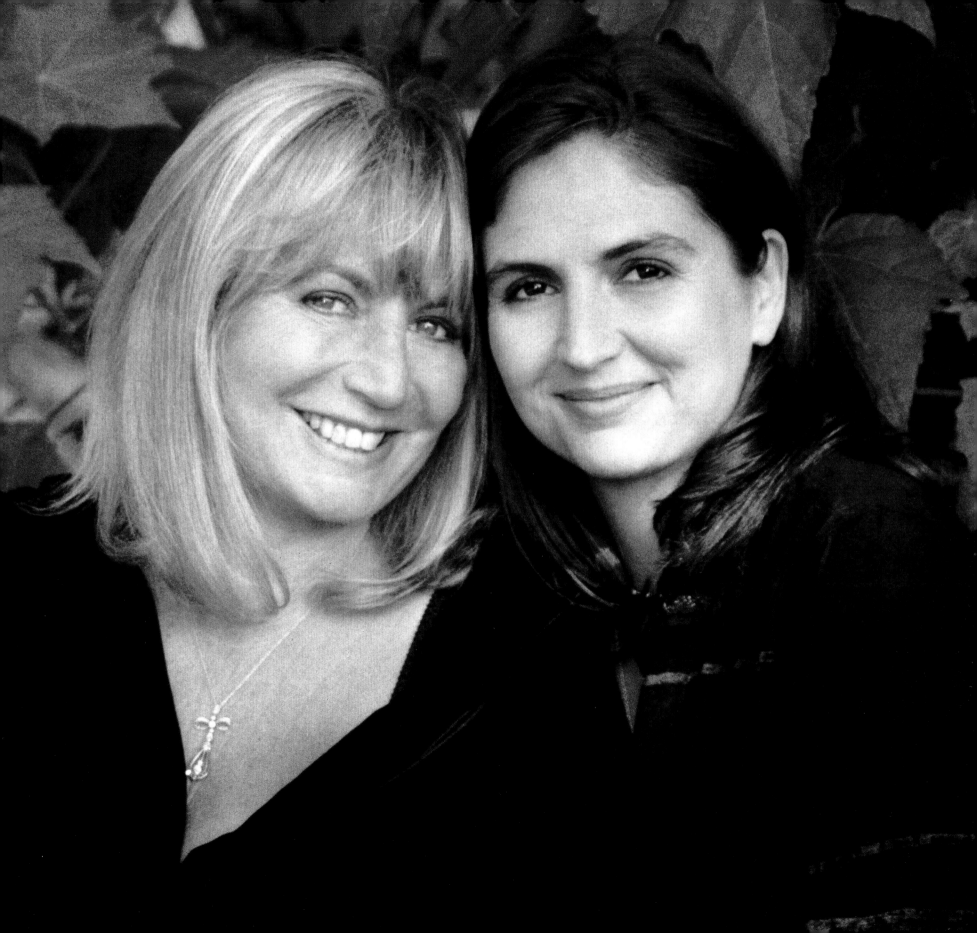

Every night when I last feed West to put her to bed,
we sit on her doll's little chair and I hum made-up gospel songs to her. I don't know
what makes me think it's gospel at all,
except soft gospel always sounds like it's about pure,
perfect love, and that's what I'm humming about.

TÉA LEONI, *actress*
MADELEINE "WEST" DUCHOVNY, *daughter*

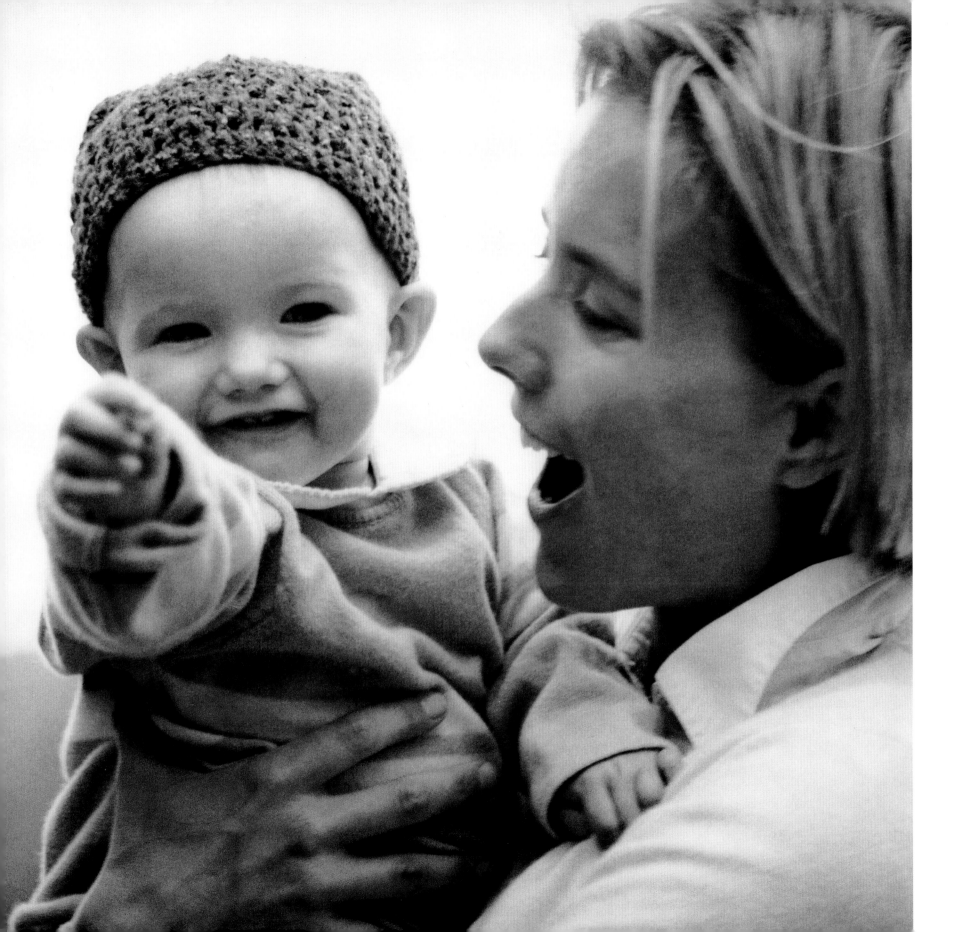

LAURA DERN & DIANE LADD, *actresses*

Diane and Laura were fun to shoot. They are both compassionate, strong, and fun-loving women.
What made the day for me was their interaction with my girls.
Their comforting way had my whole family engaged and laughing with lots of hugs and kisses. —J.O.

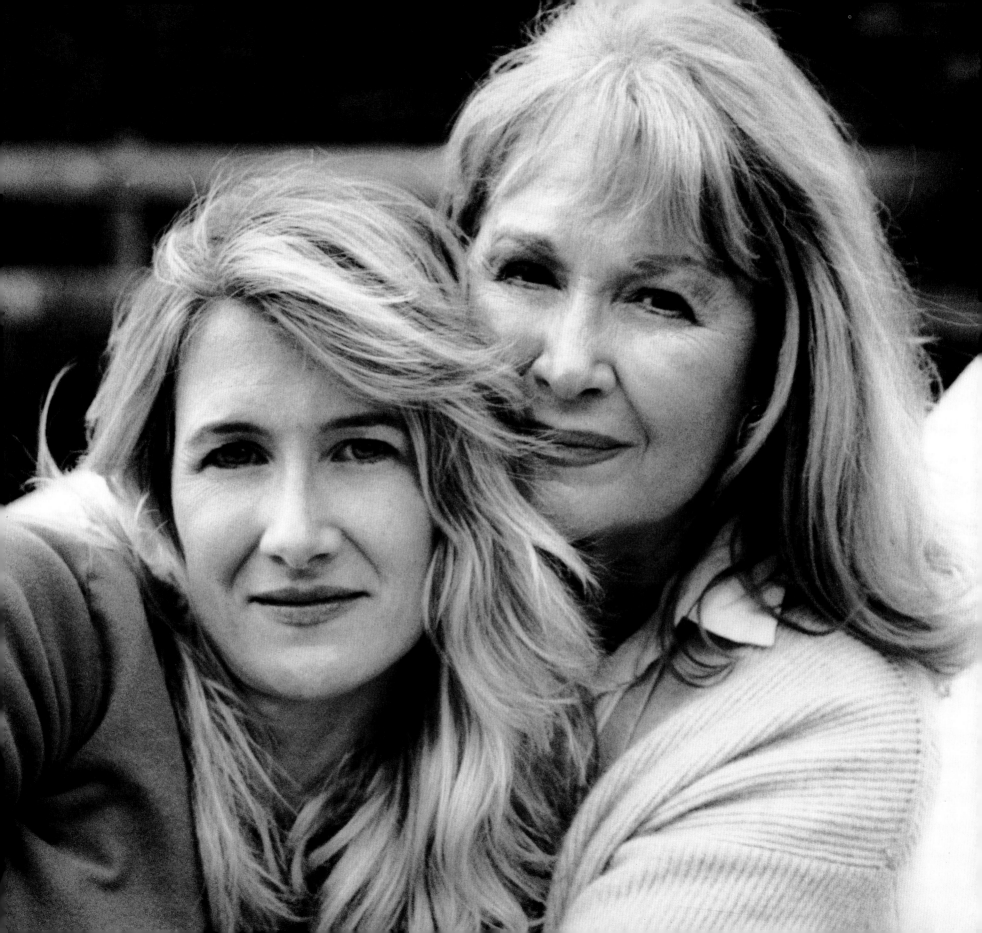

It's hard to isolate just one moment with my daughter, Emily, that stands out.
One, however, that I will never forget is when she was being baptized
together with her godsister. We were standing in front of the priest in
a small, beautiful church when I burst into tears—I have never been baptized and I don't
have any godparents. Emily, only three years old, looked at me and comforted me by saying,
"Mommy, I want my godparents to be your godparents." She held my hand.

–Colleen Camp

My Mommy makes me laugh more than anyone. She always finds the humor in everything.

–Emily Goldwyn

COLLEEN CAMP, *actress*
EMILY GOLDWYN, *daughter, with "Cinnamon"*

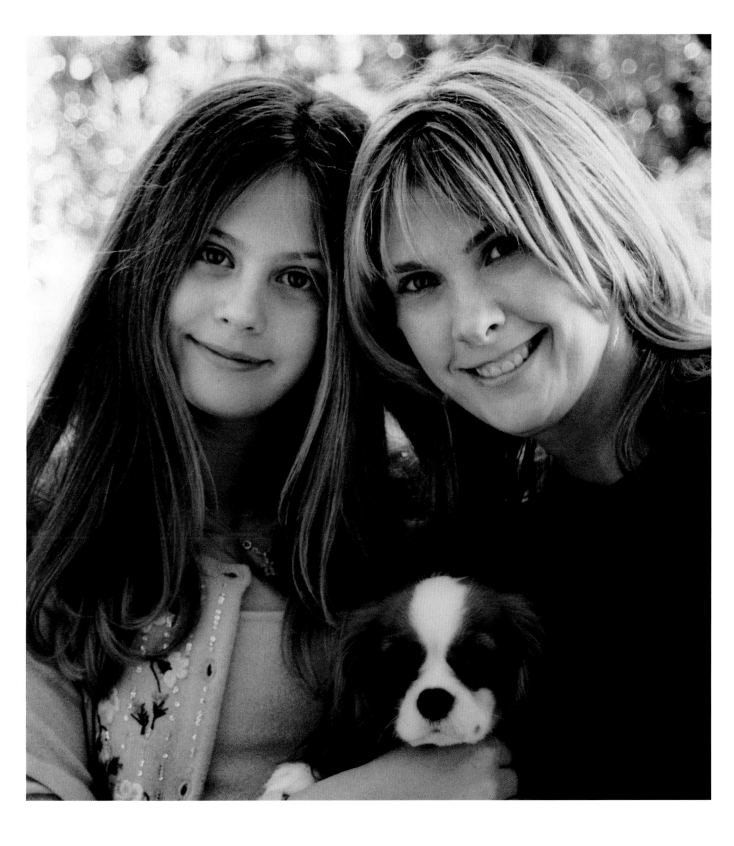

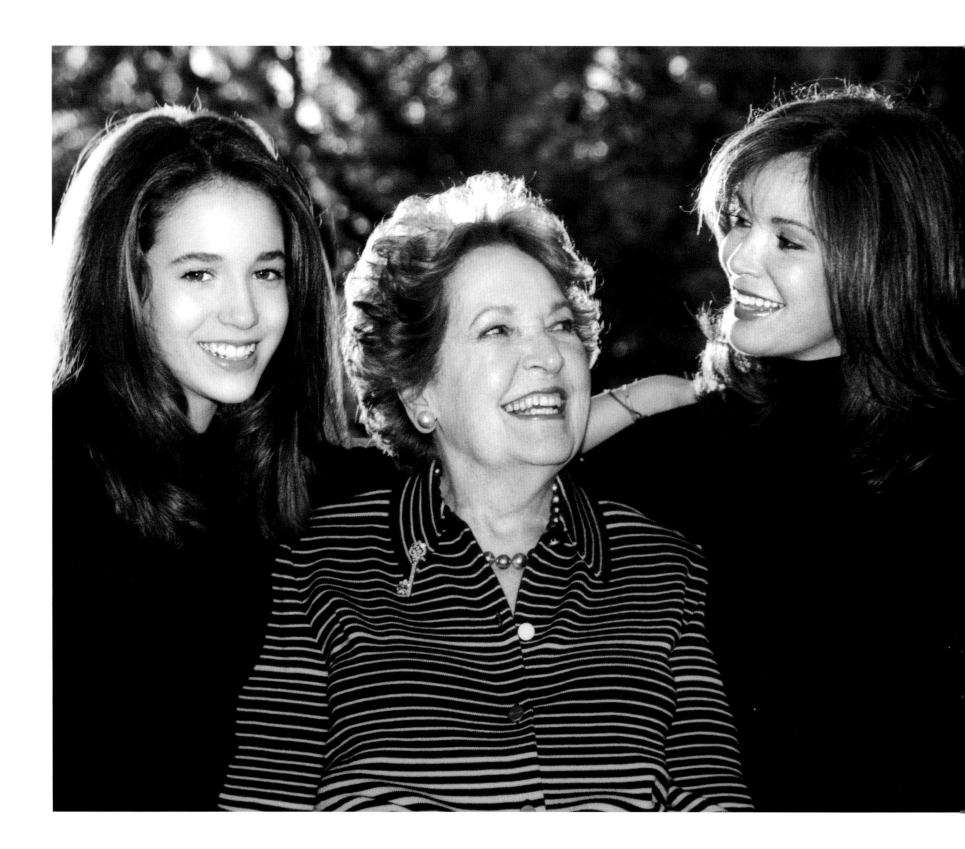

I can't bear to think of a world without them in it.
It would be a dull, colorless place. There has never been a time
I haven't felt their pure, uncomplicated love.

Mama, I thank you for your approval and your applause,
which made it possible for me to follow my own path, always
knowing I had a home to come back to, which gave me a
sense of place, of belonging, and of permanence.

As for my girlie, I want to thank you for putting me in
the sunshine every single day. Thank you for your beautiful
poetry hidden in my shoes and your sweet notes pinned to my
steering wheel. Thank you for asking the question no one ever
asks, which keeps me on my toes. Thank you for being the
sweetest, most gentle sister to Gaston.

The immensity of their gift to me is unequaled.

JACLYN SMITH ALLEN, *actress*
SPENCER-MARGARET RICHMOND, *daughter*
MARGARET ELLEN SMITH, *mother*

All of my life, I have been able to rely on my mother to be my closest confidant.
I treasure most our quiet moments talking over coffee, in the late morning, at home.
Her compassion and wonderful ability to laugh
at life's little foibles have been a great inspiration for me.

SHERYL CROW, *singer*
BERNICE CROW, *mother*

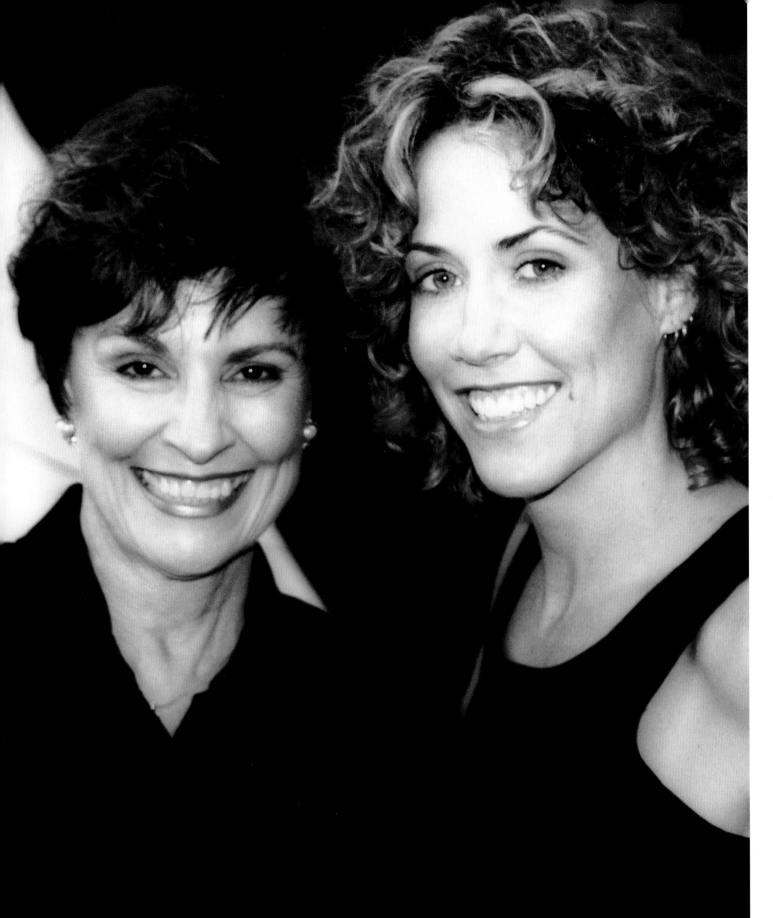

I feel it has been a privilege to be my mother's daughter.

God blessed me with her love.

Everything I know about being a mother myself has come from her.

She is unconditional love.

MARGARITA WILSON HANKS, *actress*
DOROTHY WILSON, *mother*

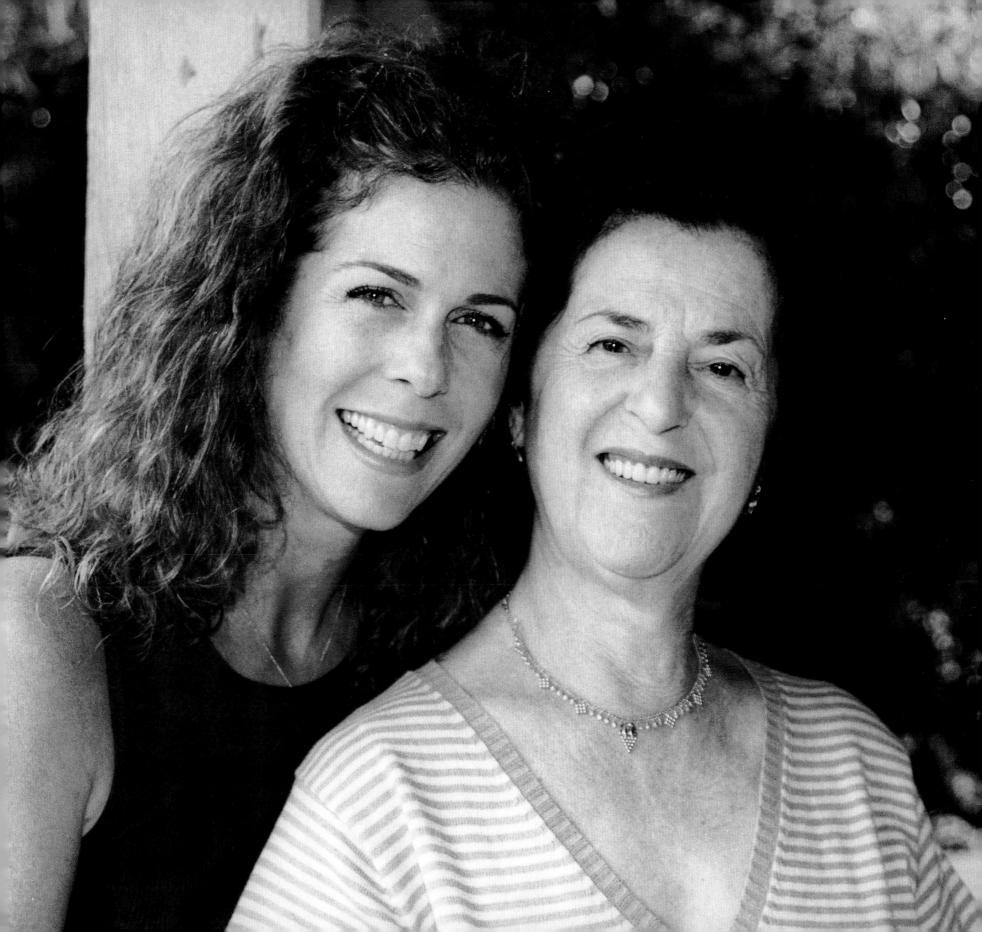

Our most nourishing moments revolve around laughter.
While laughing with my daughter, we share joy that comes from our hearts.
In her laughter, I hear the women of our family's past
and see a glimpse of our family's future.

WENDY FINERMAN, *producer*
DOROTHY CANTON, *daughter*

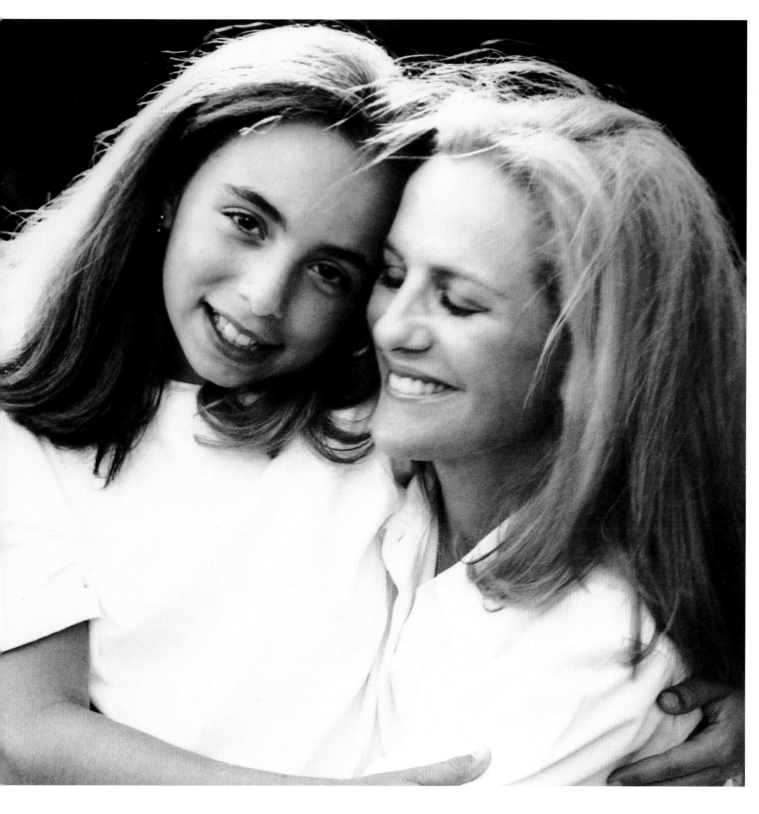

Every day.

JAMIE LEE CURTIS, *actress*
ANNE GUEST, *daughter*

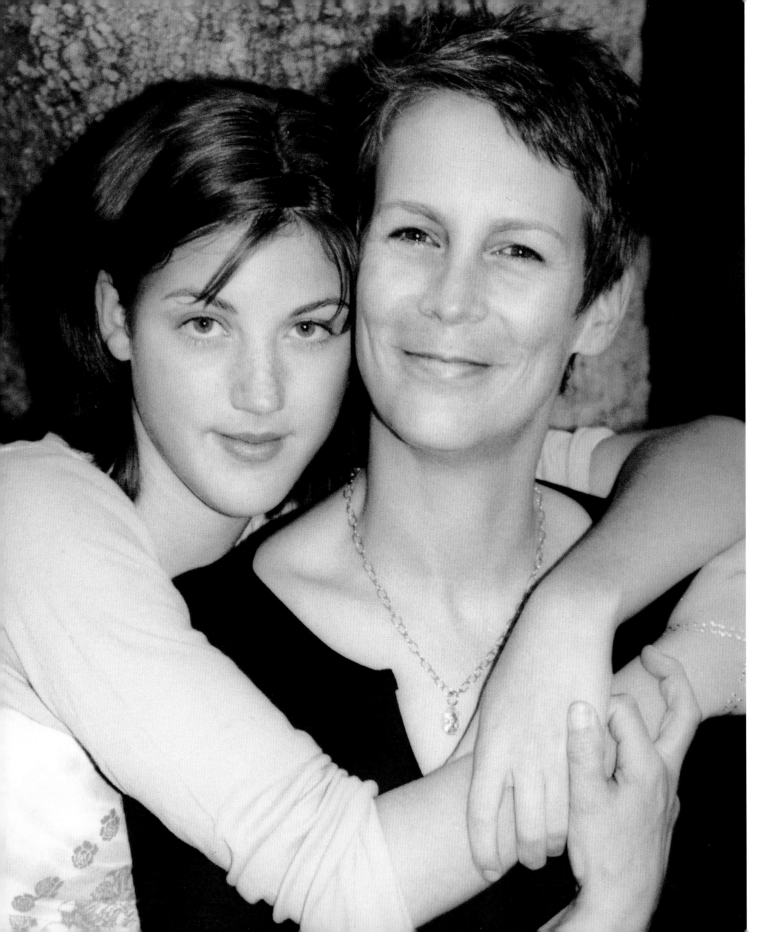

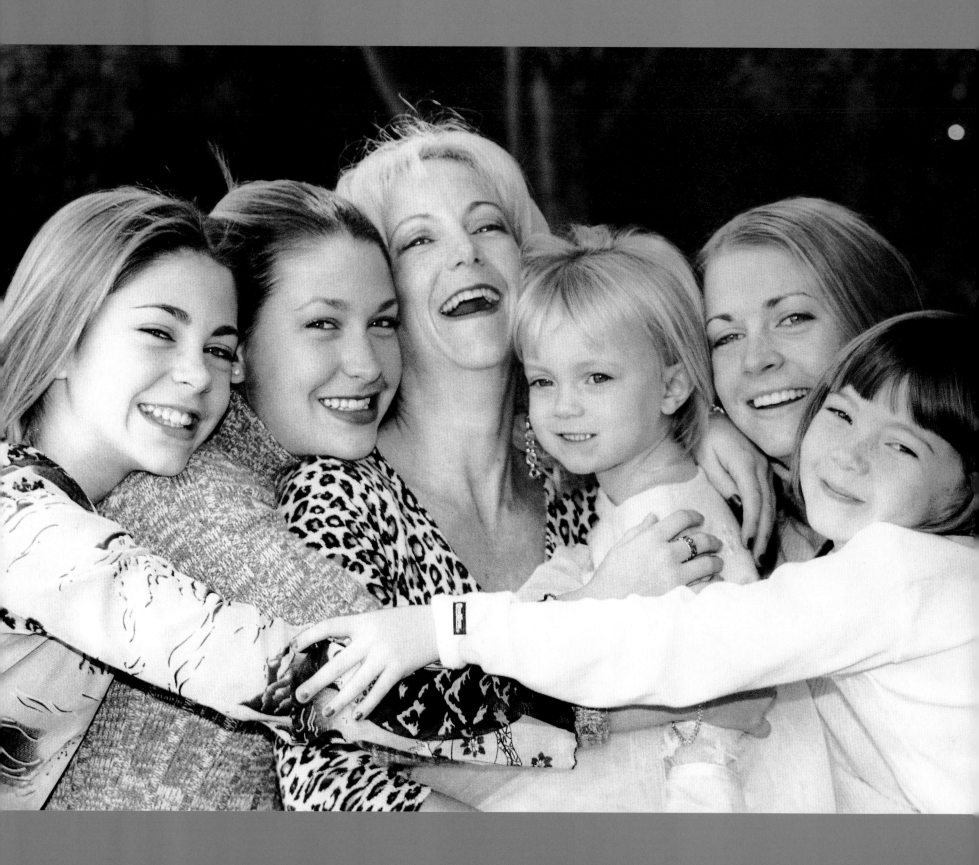

The best part about working with mom is whenever I feel lousy,

either my spirits are low or I am vomiting in the nearest trash can,

she is nearby and always knows exactly what to do.

I have learned from her that the saying is true, mother knows best.

I can't make a move without her because, somehow, she is always right.

I have learned that the more I listen to her and learn from her experiences,

the easier it is for me to get through hard times,

make difficult decisions, and save myself a lot of heartache.

MELISSA JOAN HART, *actress*
PAULA HART, *mother*
EMILY & TRISHA HART,
SAMANTHA & ALEXANDRA HART-GILLIAMS, *sisters*

Mother and Daughter
What could make me even happier?
To part is like leaving half your heart behind.
—*Mavis Spencer, 8 years*

I call my Mavis perfection because she is.
She is unfolding with such joy and boldness and openness.
I try to stay out of the way. Yes, I certainly am the mommy
and I keep her fingers out of the electrical sockets.
But we are all individual expressions of God.
I get to walk in this time with her to help her find her voice.
It is already a richer, mightier, more connected song than I sing.
She has awakened me. She is also a real hoot!
—*Alfre Woodard Spencer*

ALFRE WOODARD SPENCER, *actress*
MAVIS SPENCER, *daughter*

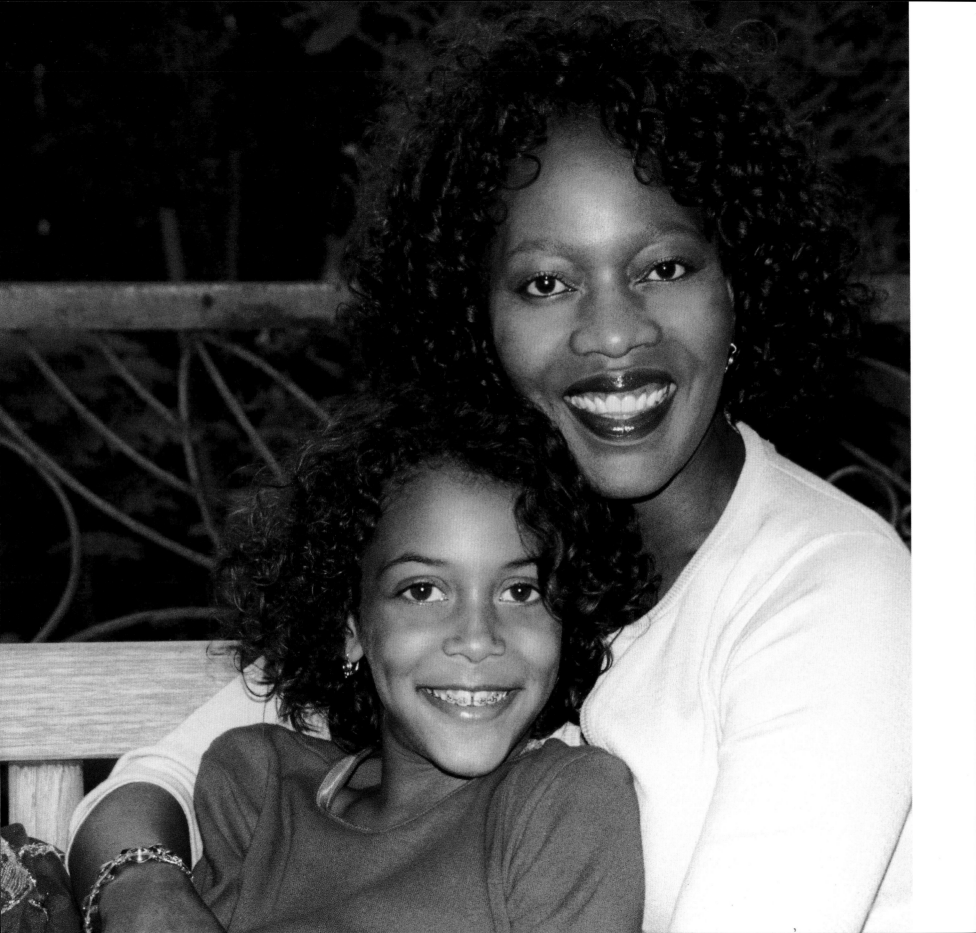

CAROL BURNETT, *actress*
JODI & ERIN HAMILTON, *daughters*

The thing that struck me the most was the easy manner they had with one another.
One could assume even their hearts beat the same rhythm. –J.O.

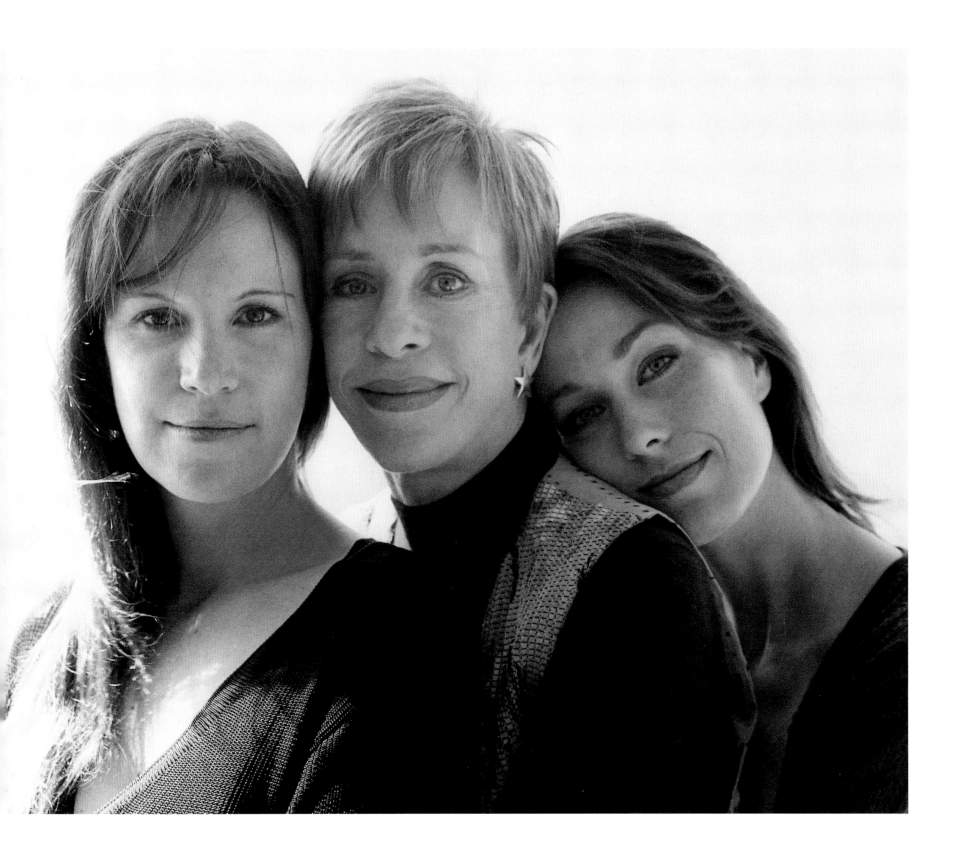

There is no greater joy than the joy that a child brings.

FAITH HILL, *singer*
MAGGIE & GRACIE McGRAW, *daughters*

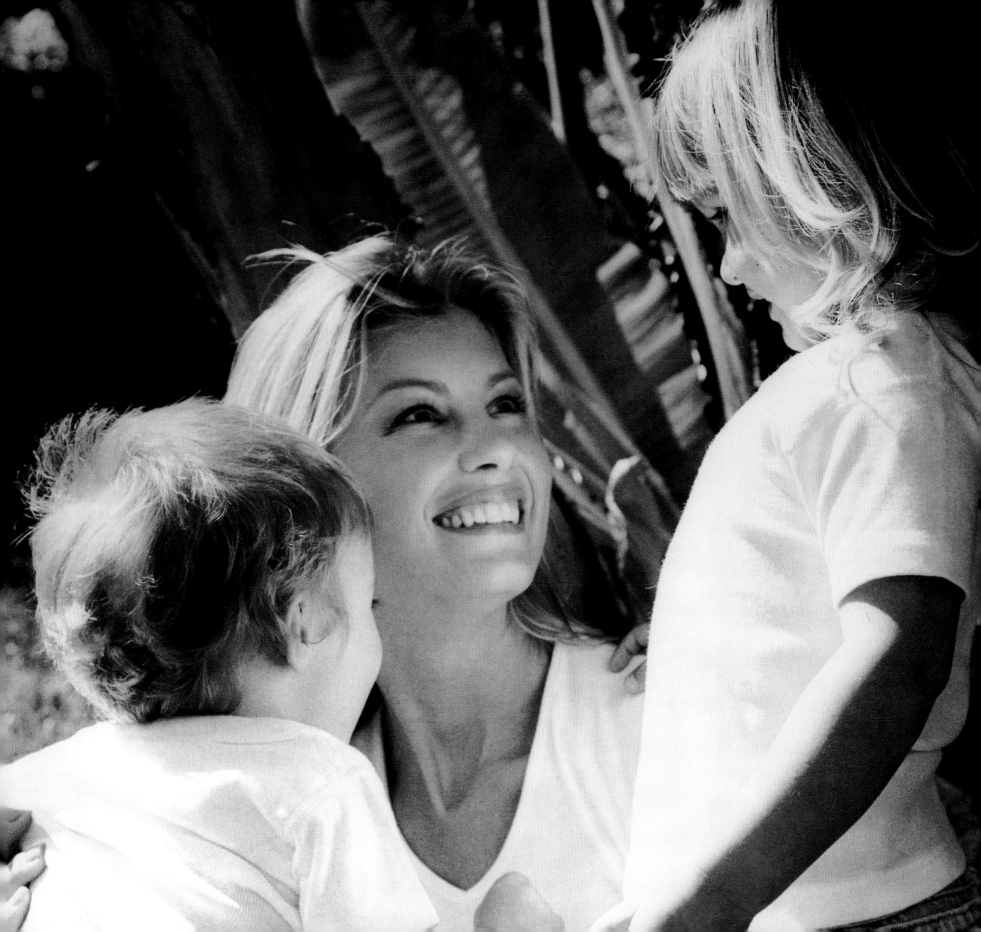

My mother always taught me; now she says that I am teaching her.

KATE CAPSHAW, *actress*
BEVERLY NAIL, *mother*

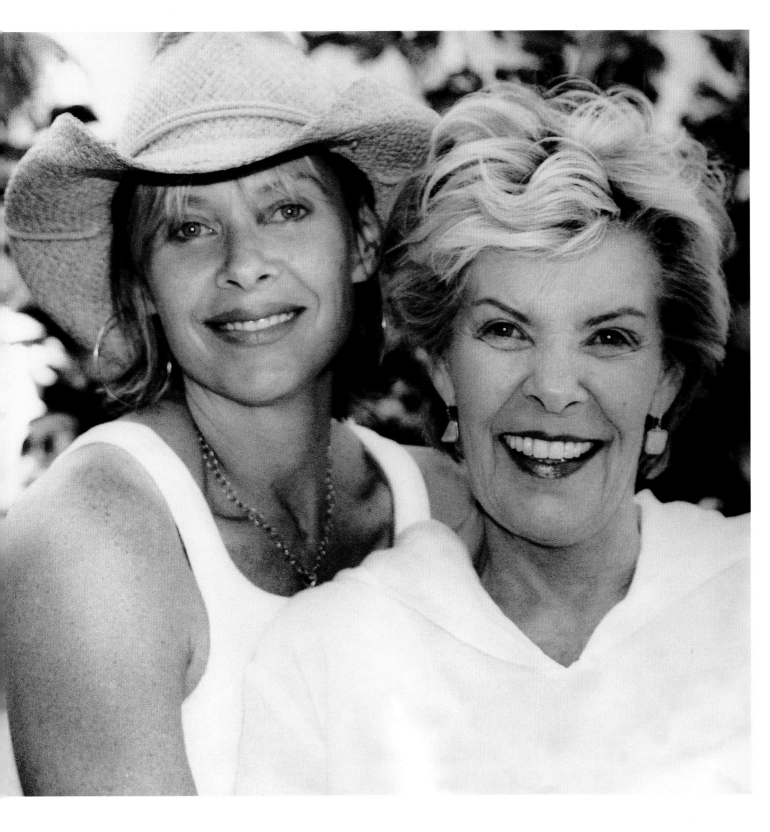

This Mother's Day, May 14, 2000, I received a card from Amanda.
The printed words were, "Little girls love their Moms—even after they're all grown up!"
The written words were, "Despite all of the talk about girls and their fathers,
there is nothing that compares to two women—a mother and daughter
who share as special a bond and friendship as we do now.
That being said, I will never stop spending the night and
allowing you to take as amazing care of me as you always do!
You really are the most extraordinary mother, wife, friend, and, of course, doctor.
—Lots of love, Amanda"

Please note: Amanda has her own place and I'm not a doctor,
but when she's sick, I nurse her back to health.
—*Wendy Goldberg*

WENDY GOLDBERG, Hollywood Moms *contributing editor*
AMANDA GOLDBERG, *producer*

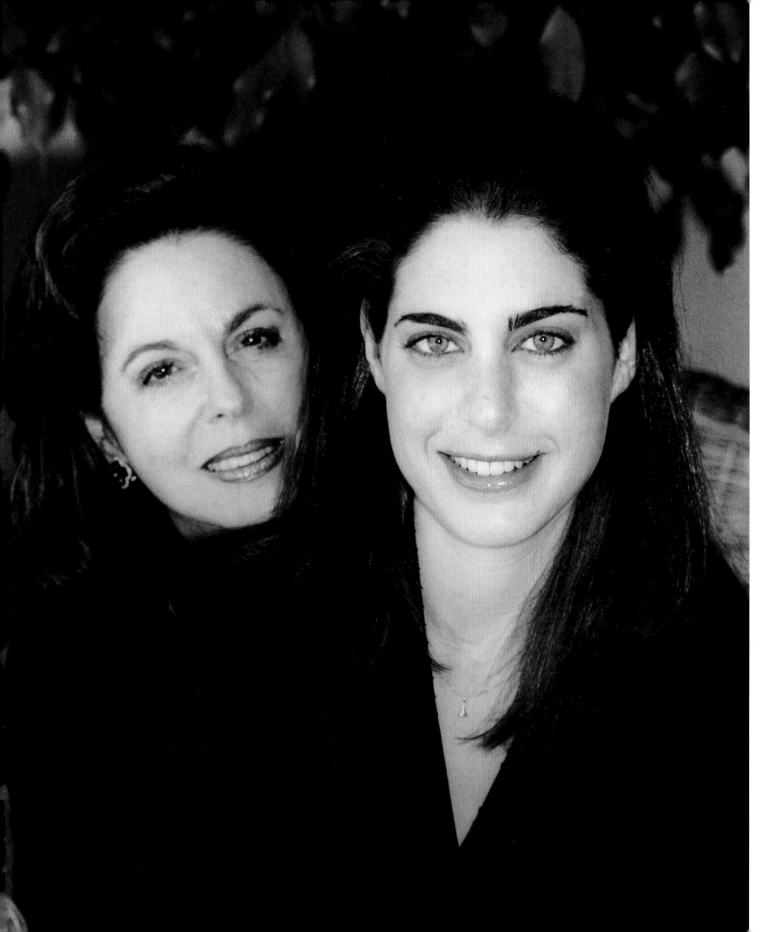

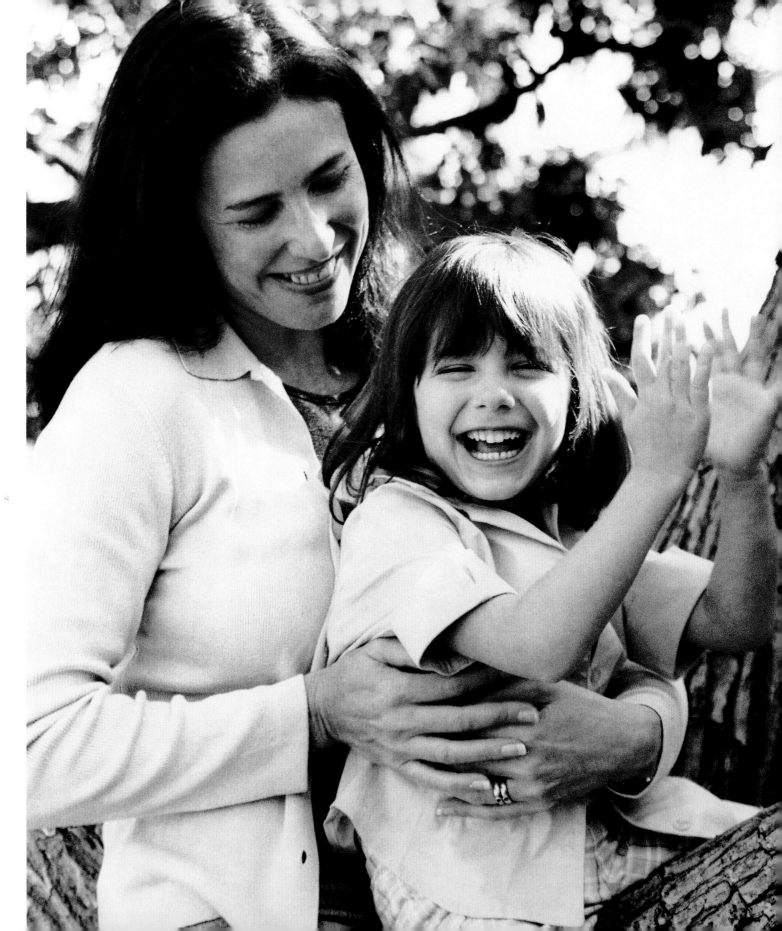

No matter how bad a day I may have had,
when I walk through the door and hear,
"Mommy?" and I see that bright, amazing face,
all the clouds go away and my heart is full.

MIMI ROGERS, *actress*
LUCY ROGERS-CIAFFA, *daughter*

My mother was my strength and discipline.
She made it possible for me to follow all of my dreams and become what I am today.

—Jennifer Lopez

I have always taken pride in my daughter's accomplishments.
She works extremely hard and deserves every success that she has achieved. I love you.

—Mom

JENNIFER LOPEZ, *actress & singer*
GUADELUPE LOPEZ, *mother*

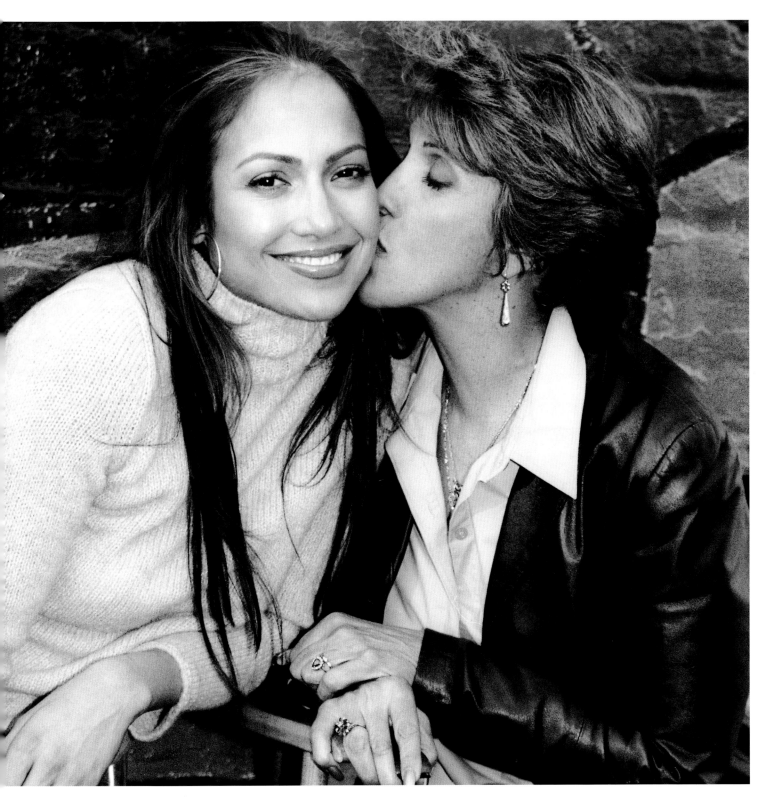

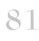

Colette Blue fills me up every moment. When the external world depletes my energy,
Coco energizes me with her innocence, her laughter, her wonder, and her overflowing love.
She is the sunshine in my universe; the song in my heart.

SHIVA ROSE McDERMOTT, *actress*
COLETTE BLUE McDERMOTT, *daughter*

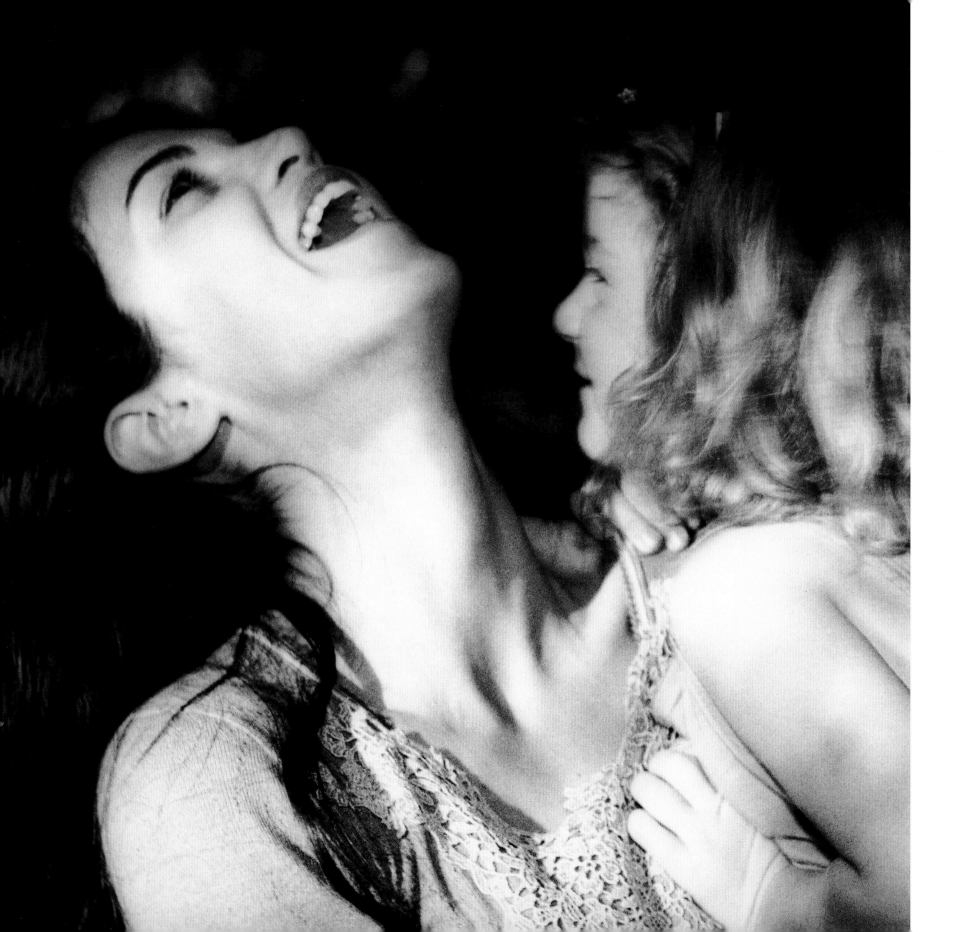

i'm so blessed to have you in my life
i hope i've been a good enough daughter
without bringing too much stress in your life!
i love you in so many ways
you're more than just my mom

you're a person who's
touched me
helped me
kept me strong
even if that minute
you couldn't be there
your voice stayed strong
and remained in my head

you gave me life
and taught me how to live
now it's my turn
is there something i can give

thank you for being
and for being my friend
i will always have your back
the way you've had mine
through thick and thin
in the hospital
you were always there
seeing your face
gave me strength
to get out of there

you're a major part of me
in my heart everyday you live
and to you gayle watkins
this poem i give
to my mother
i love you!

TIONNE WATKINS (T-BOZ), *singer*
GAYLE WATKINS, *mother*

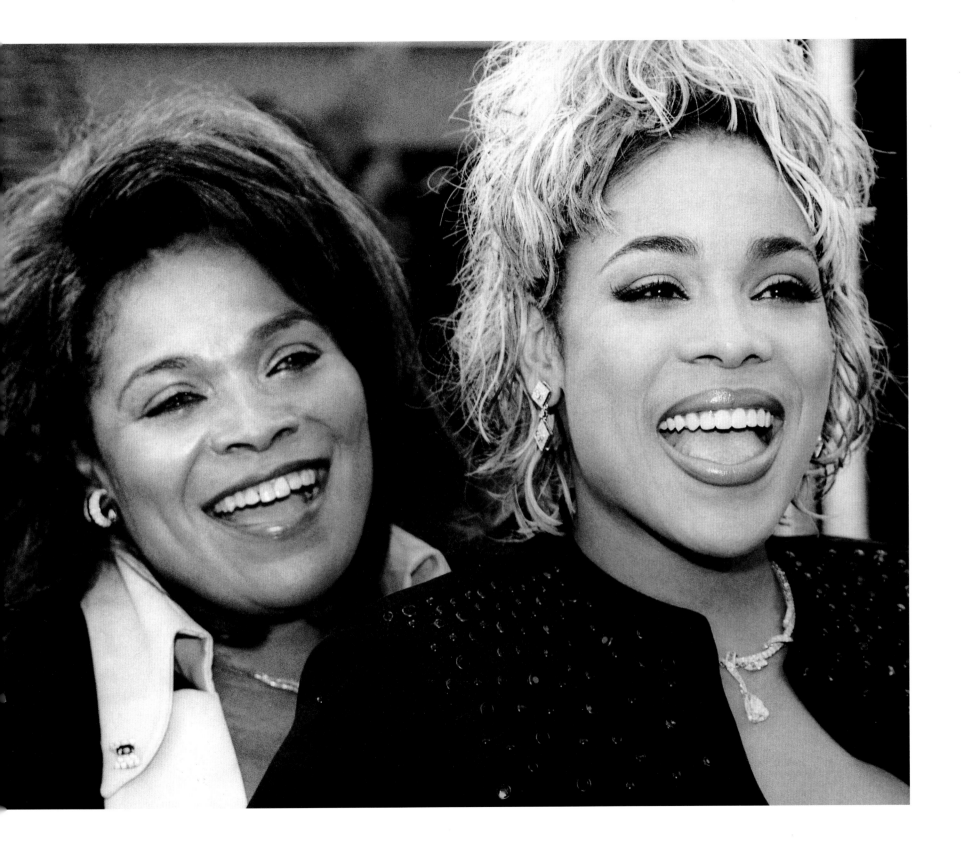

I will never forget the morning we went to the hospital.

As we pulled out of the garage, the sun was just coming up over the mountains.

It was the most beautiful morning I had ever seen.

I was on my way to the hospital to meet my new daughter,

who had been living inside of me for nine months.

It was a magical moment.

VANNA WHITE, *game show co-host*
GIOVANNA SANTO-PIETRO, *daughter*

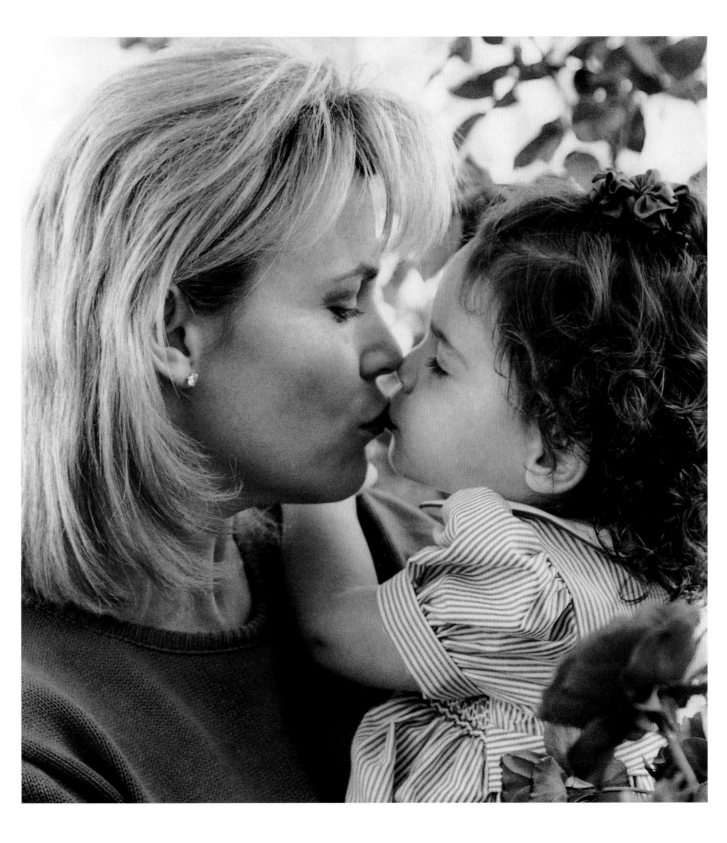

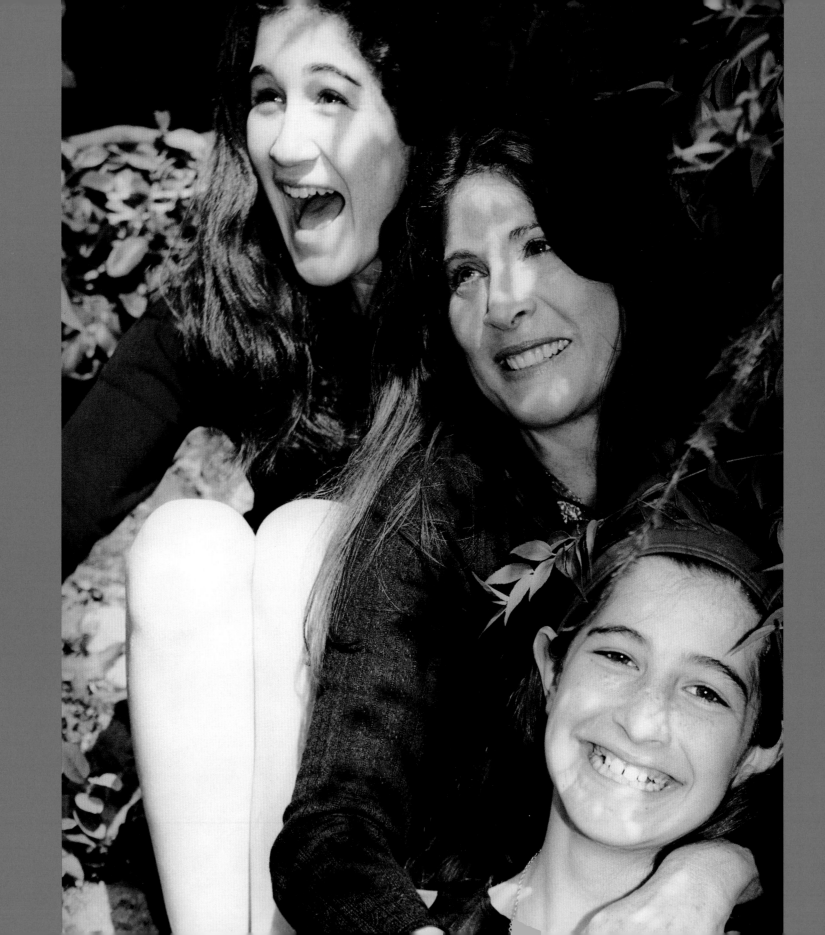

Every moment with my kids is delicious.

I wake them by lying under the covers and holding them.

Those moments before they awake (and realize they have to go to school) are precious

and are a very calming way to start our day. I put them to bed the same way, lying close,

reading and talking. I've been reading *Jane Eyre* to Claire, for over a year, and we

both do and don't want it to end. We travel often as a family and laugh constantly.

The moments away from the routines and pressures of home are special in their purity.

I'd rather be with my family than anyplace on earth.

CATHY WATERMAN, *jewelry designer*
CLAIRE & COCO KISLINGER, *daughters*

After keeping my breast cancer a secret from Chloe for eight months,
someone in Australia told her, and she came running home very upset.
"Why didn't you tell me?" "I didn't want to scare you," I replied.
Her best friend, Colette Chuda, had died of cancer one year before
"But, mummy, I could have taken care of you!"

OLIVIA NEWTON-JOHN, *actress & singer*
CHLOE LATTANZI, *daughter*

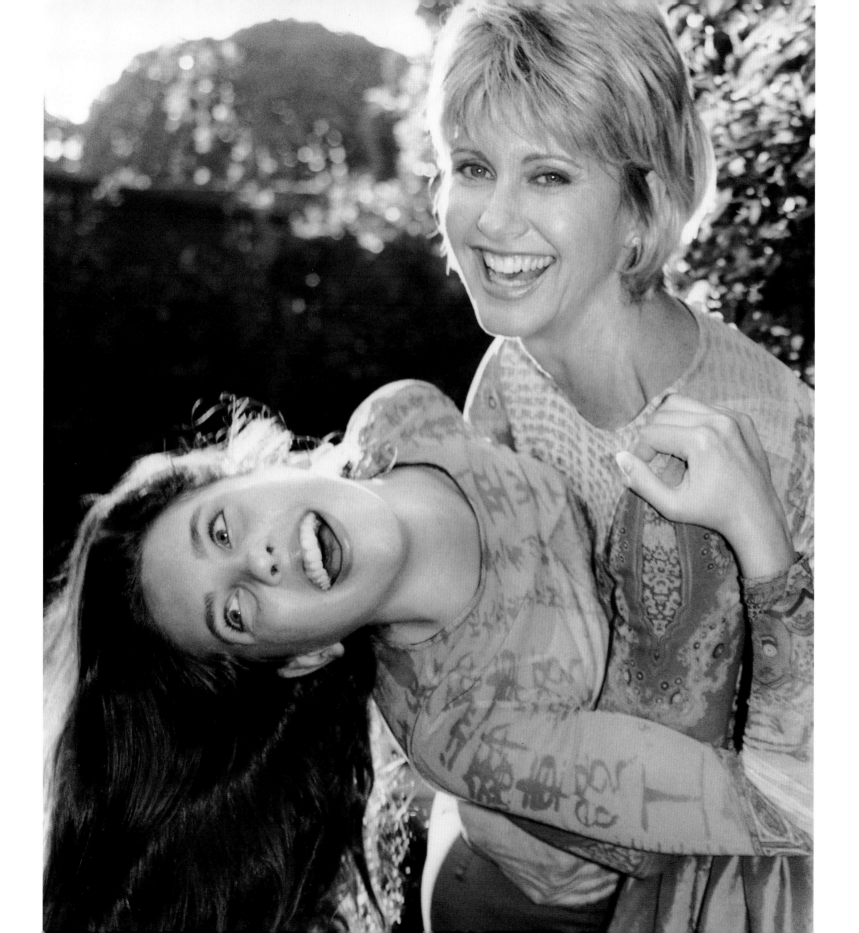

It is all the little things that seem trivial and insignificant—the smells, the giggles, the
snuggles, the smiles, and, even better, the uncontrollable laughter . . .
reading a book together in front of the fireplace, the sharing of stories about friends and
school, the anticipation of watching the rice krispie treats being pressed into the pan, the
endless questions—but, most importantly, the unconditional love.
It's amazing to experience that. You don't have to look great or feel up, or sound happy.
You can have every flaw hanging out to the world.
Completely exposed, you still feel loved and that feels good.

KATHY SMITH, *fitness expert*
KATE & PERRIE GRACE, *daughters*

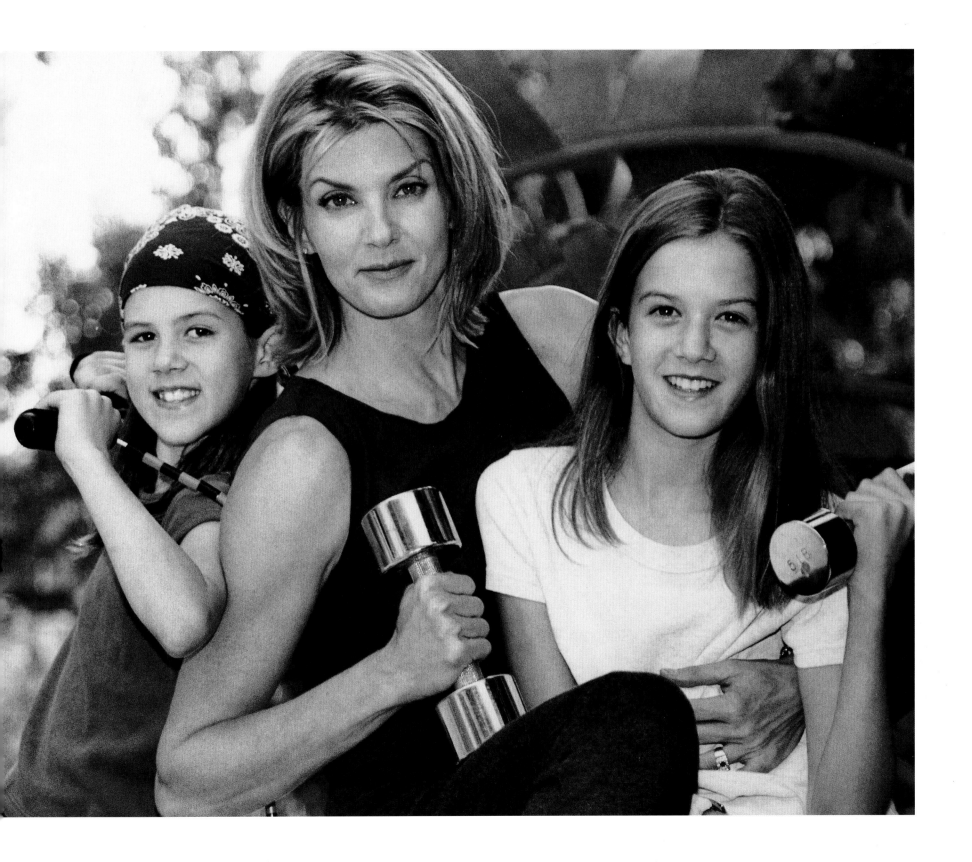

The most tender moment that I ever shared with my daughter was the first time
I looked into her eyes after she was born. There's no experience like it in the world.

SELA WARD, *actress*
ANNABELLA RAY, *daughter*

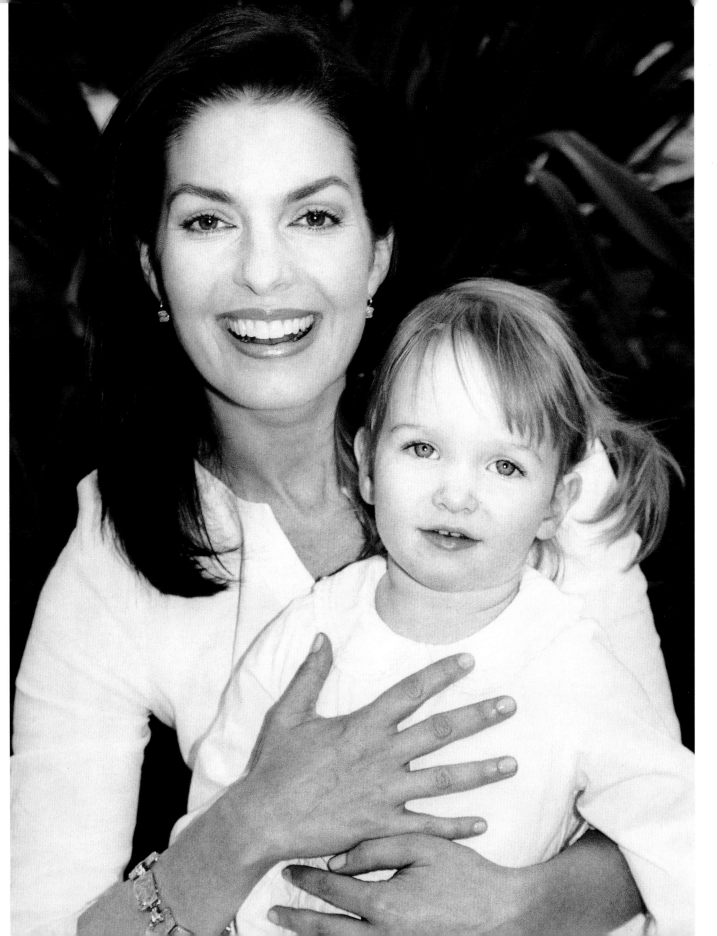

Mommy was in a big play in New York.
I was six years old, stepping off the plane from
Los Angeles to visit her for Easter holidays.
She was down on one knee in her glamorous
polo coat, her hair blowing in the crisp
New York winter wind, her arms open wide.
I remember the smell of her perfume,
the emotion in her soft voice,
the embrace that lasted an eternity.

ANNE ARCHER & MARJORIE LORD, *actresses*

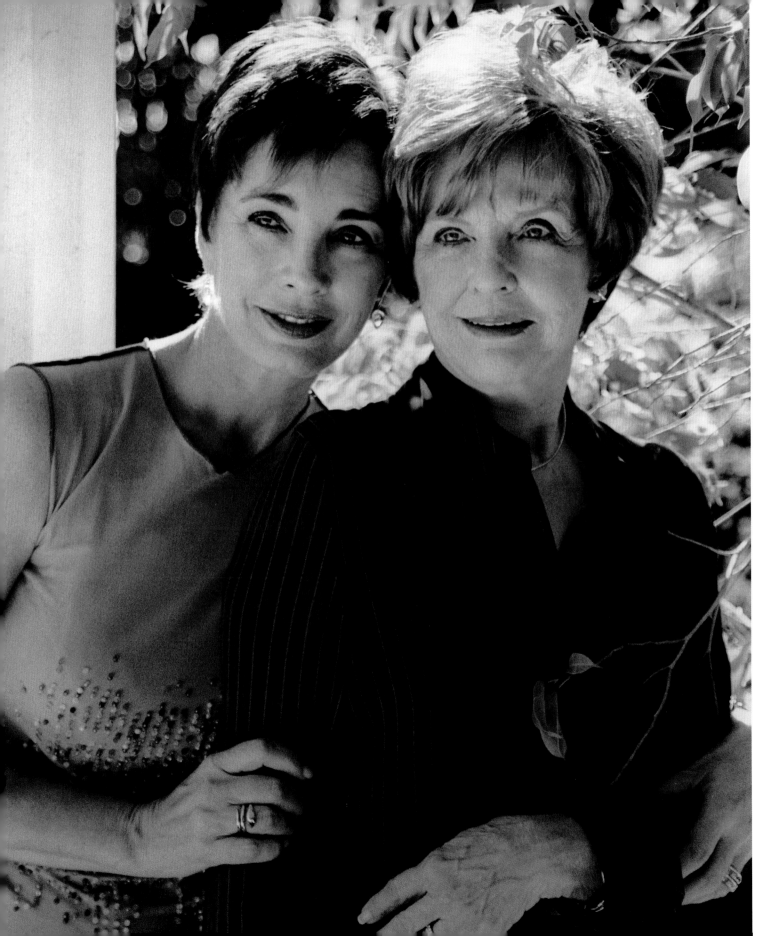

One of the most amazing moments of my life happened a few days after Ella was born.
I had just finished nursing her and she had fallen asleep, so I laid her down on the bed with me.
It was my son Jett's bedtime and he wandered in to kiss me goodnight.
Normally it can take us up to an hour to get him to sleep, but he was exhausted from playing all day.
When he saw how cozy we were he crawled into bed with us, curled up in my arms,
and fell asleep in five minutes. I had both of my babies peacefully asleep in my arms.
I have never felt so happy or alive, nurturing my children and being nurtured by them.

KELLY PRESTON, *actress*
ELLA BLUE TRAVOLTA, *daughter*

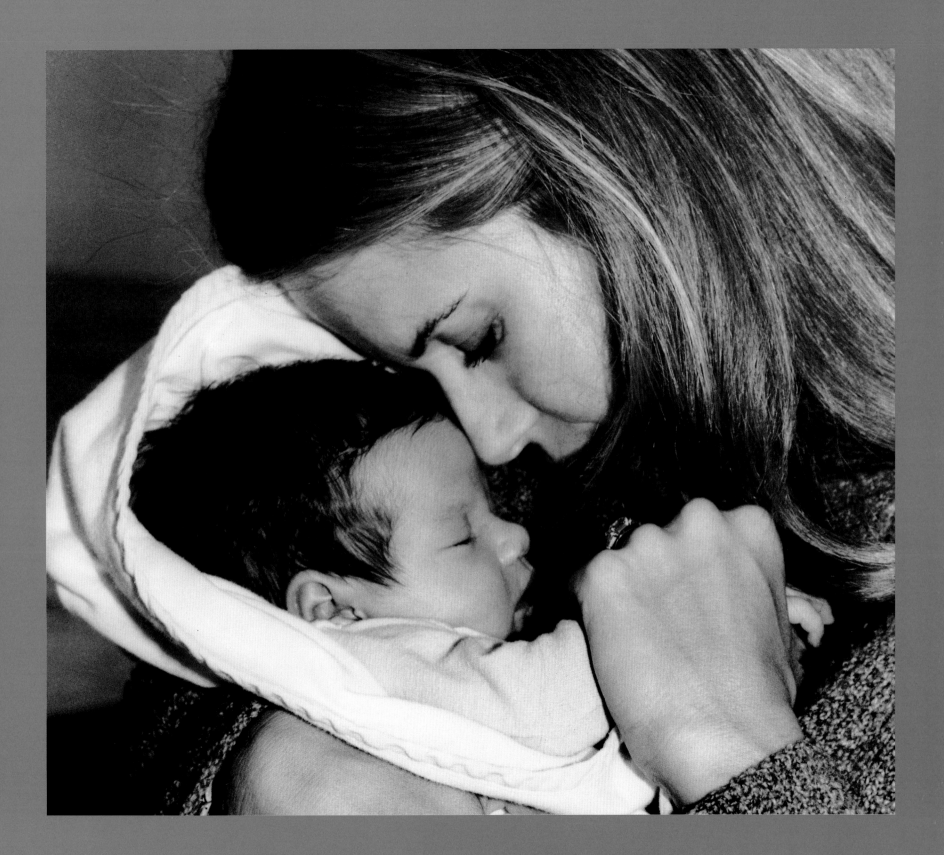

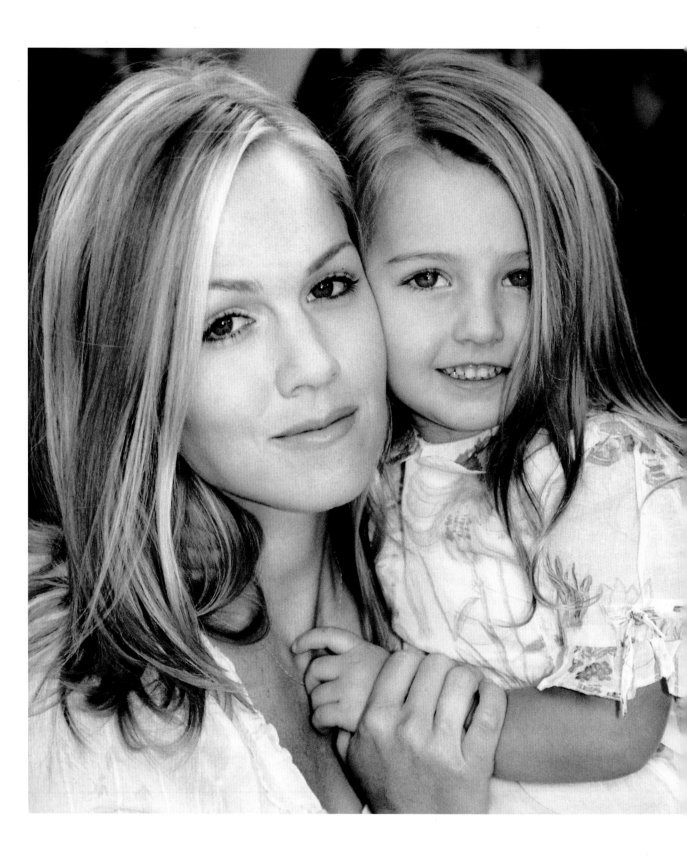

I love when Luca just completely relaxes in my arms. It is such a safe, warm feeling.

Luca always lights up and runs into my arms at full speed as if to say,

"I missed you just as much as you missed me."

Every morning the first thing I hear is "Good morning, my mommy."

You can't help but smile, no matter how early it is.

JENNIE GARTH, *actress*
LUCA BELLA, *daughter*

My most nourishing moments are when we snuggle in the big white bed.

RACHEL HUNTER, *actress*
RENEE STEWART, *daughter*

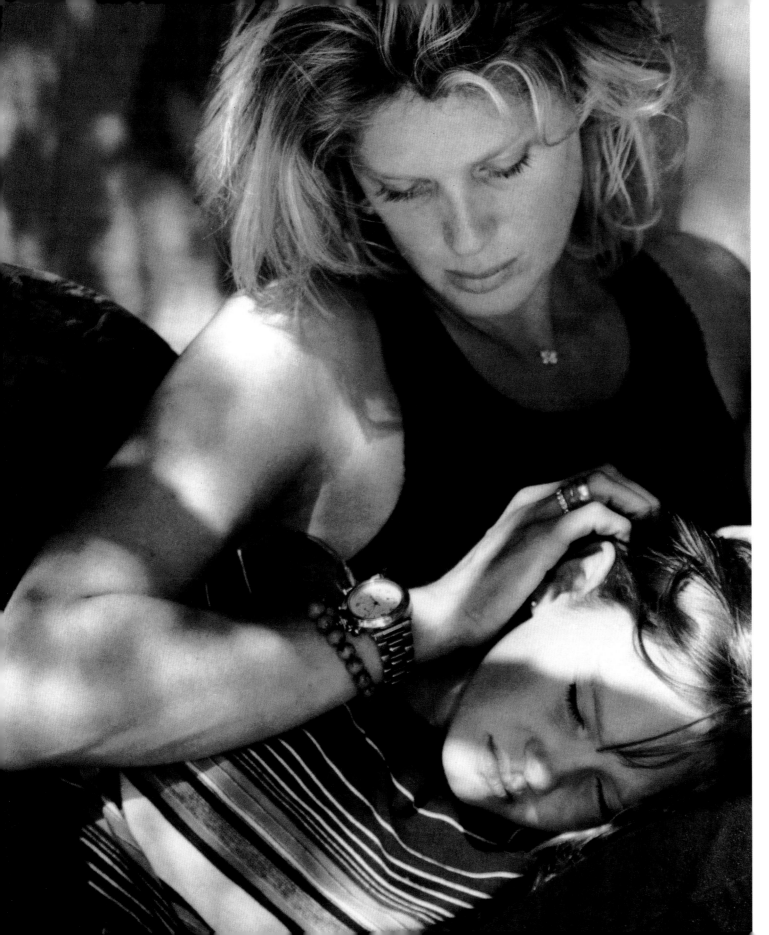

Two girls then
Two women now
Wisdom

PRISCILLA PRESLEY, *actress*
LISA MARIE PRESLEY, *singer & songwriter*

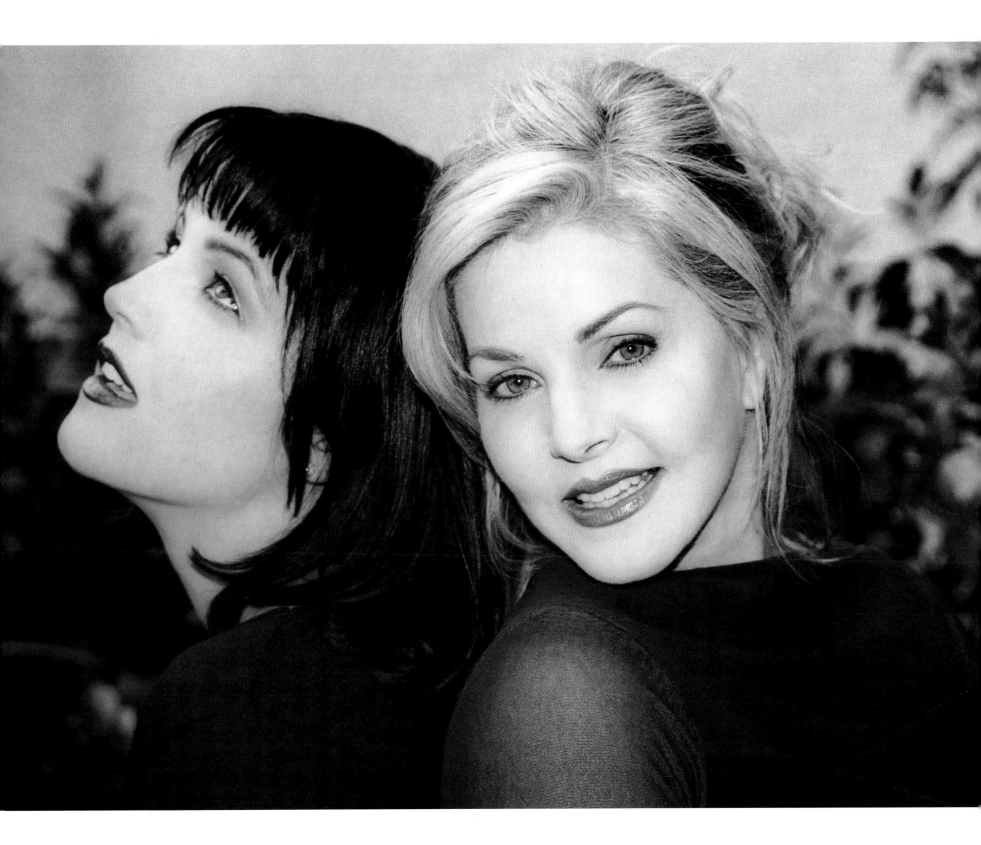

CONNIE STEVENS, JOELY & TRICIA LEIGH FISHER, *actresses*

Connie and her girls seemed very committed to each other and respectful of one another.
They shared a closeness that was beautiful. She seems like the mom who you know will always be there to listen. —J.O.

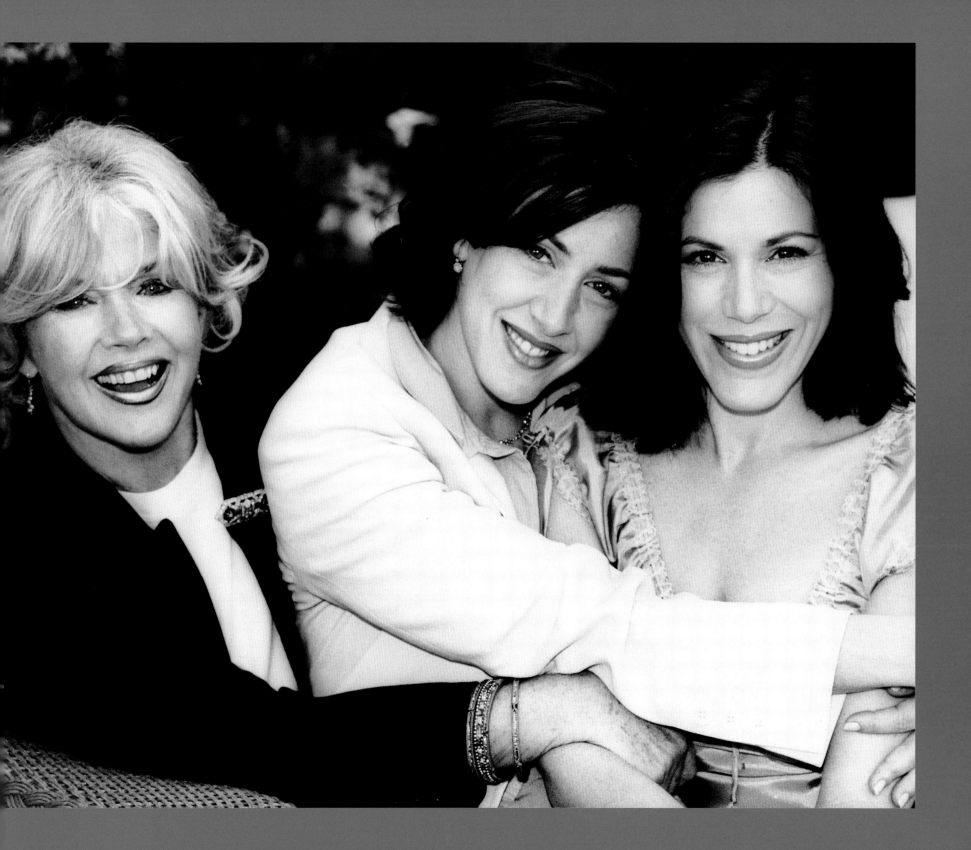

ELLEN BARKIN, *actress*
ROMY BYRNE, *daughter*

Ellen was not really prepared for this picture, but the minute Romy was in her arms motherhood took over.
She is totally in love with her children, Romy and Jack, and they are her life. —J.O.

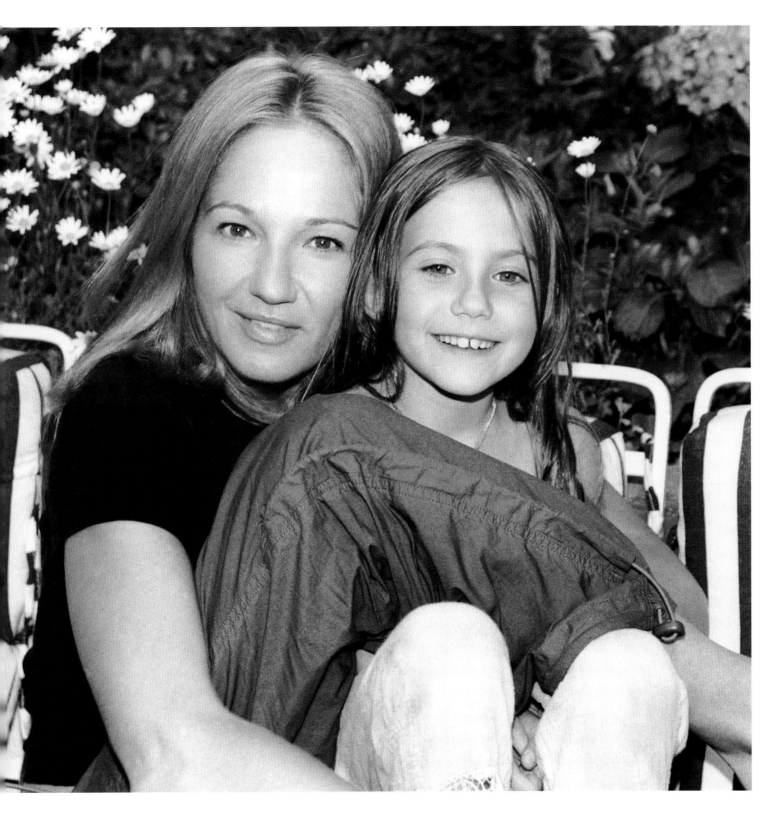

My most nourishing moment as Kate's
mother came from her support and love
and presence during and after the loss of
my mother.
–Goldie Hawn

To know and respect the wisdom from
your mother is rare in itself.
I feel blessed to share honest love and
honest words unconditionally with her.
Talk about nourishing!
–Kate Hudson

GOLDIE HAWN
& KATE HUDSON, *actresses*

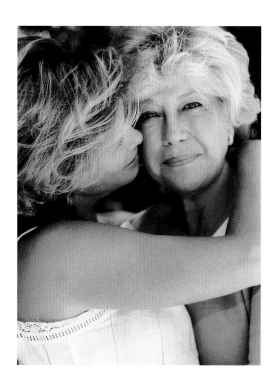

To Evelyn Ostin, the ultimate Hollywood Mom, the mother, grandmother, or mother-in-law anyone would want to have.
Her generosity and beauty have graced the world of Hollywood: She is a connection to the spiritual mother lode for actors,
producers, executives, and spiritual advisors. In Evelyn's world everyone is equal. She possesses the greatest gifts anyone could want—
the abilities to live life to its fullest, to accept people as they are, and to pursue and realize her dreams.
She truly has been an inspiration in my life. And, for the last twenty-one years, she has remained a breast-cancer survivor.

From Anika, Leyla, Annabelle, and myself—we all say thank you.
—Joyce Ostin